Edwin Deakin

California Painter of the Picturesque

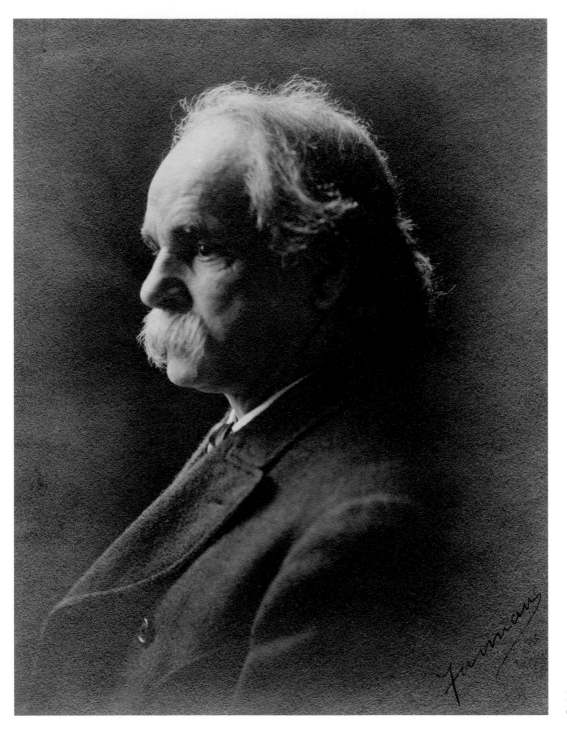

PORTRAIT OF DEAKIN, c. 1905

Robert Henry Furman, photographer.
Collection of Marjorie Dakin Arkelian

EDWIN DEAKIN

CALIFORNIA PAINTER
of the PICTURESQUE

SCOTT A. SHIELDS, PH.D.

INTRODUCTION BY ALFRED C. HARRISON JR.

CROCKER Art Museum

216 O STREET • SACRAMENTO, CA 95814

(916) 264-5423 • FAX (916) 264-7372
www.crockerartmuseum.org

2008

Published by Pomegranate Communications, Inc.
Box 808022, Petaluma CA 94975
800 227 1428 707 782 9000
www.pomegranate.com

Pomegranate Europe Ltd.
Unit 1, Heathcote Business Centre
Hurlbutt Road, Warwick
Warwickshire CV34 6TD, UK
[+44] 0 1926 430111
sales@pomeurope.co.uk

Cover: Edwin Deakin (American, b. England, 1838–1923), *Palace of Fine Arts and the Lagoon,* c. 1915.
Oil on canvas, 32 3/8 x 48 3/8 in. Crocker Art Museum, long-term loan from the California Department
of Finance, conserved with funds provided by Gerald D. Gordon.

Library of Congress Cataloging-in-Publication Data
Shields, Scott A.
 Edwin Deakin : California painter of the picturesque / Scott A. Shields ; introduction by
Alfred C. Harrison, Jr.
 p. cm.
 Catalog of an exhibition at the Crocker Art Museum.
 Includes bibliographical references and index.
 ISBN 978-0-7649-4351-5
 1. Deakin, Edwin, 1838–1923—Exhibitions. 2. Landscape in art—Exhibitions. 3. California—
In art—Exhibitions. I. Deakin, Edwin, 1838–1923. II. Crocker Art Museum. III. Title.
 ND237.D333545A4 2008
 759.13—dc22
 2007030421

Pomegranate Catalog No. A144
Designed by Lynn Bell, Monroe Street Studios, Santa Rosa, California
Printed in China

17 16 15 14 13 12 11 10 09 08 10 9 8 7 6 5 4 3 2 1

CONTENTS

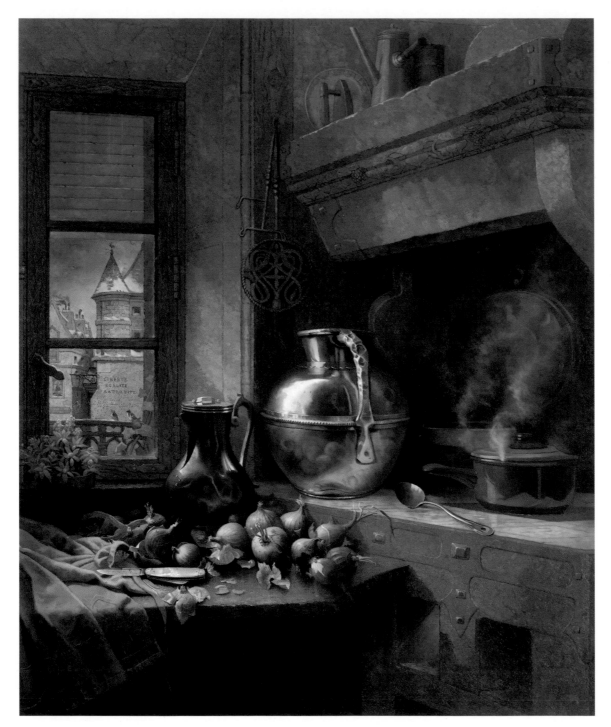

LE COIN DE CUISINE
(KITCHEN CORNER),
1883

Oil on canvas, 48$\frac{5}{16}$ x 40$\frac{7}{16}$ in.
Crocker Art Museum, long-term
loan from the California
Department of Finance,
conserved with funds provided
by Gerald D. Gordon

6

ACKNOWLEDGMENTS

The Crocker Art Museum, the first public art museum in the West, is one of the primary resources for the study and appreciation of the art of California. It is exceptionally appropriate that the museum should collect and exhibit the work of a premier yet underrecognized California artist, Edwin Deakin.

Deakin's paintings contribute much to the Crocker's collection of early California art, and his Swiss, French, and English subjects significantly enhance the museum's holdings of nineteenth-century European art. Many of his paintings date from the period when E. B. and Margaret Crocker were acquiring work directly from California artists and building their gallery (completed 1872). The paintings thus complement not only their collection, but also the gallery's Victorian-Italianate architecture.

Deakin knew the Crocker Art Gallery well and thought highly of it. He visited in 1888, in the company of fellow artists Norton Bush, Chris Jorgensen, and others, three years after Margaret Crocker donated the gallery building and its collections to the citizens of Sacramento. Impressed, Deakin was warm in his commendation:

> He says he doubts if in the Louvre the doors are finer than in this gallery. Of the paintings Mr. Deakin gives a frank and critical opinion, commending most in comparison with similar works abroad, and finding others below a good standard, but as a whole thinks the city possessed of a great treasure in such a property. The artists agree that the School of Design is situated in rooms not surpassed, if equaled by any.[1]

Deakin painted and showed his work in Sacramento. He passed through the city frequently on his many Tahoe trips and, in the latter 1870s, produced views of the American River. He exhibited at the California State Fair in Sacramento in 1879 and in every year between 1886 and 1889; one of his five entries at the 1886 fair won a silver medal for "Best Fruit Piece," and in the following year he took the fair's award for the most meritorious display of oil paintings by a resident California artist.[2] Among the works displayed in 1887 was *Mount Blanc,* his Paris Salon painting, now on long-term loan to the Crocker.

In 1888, Deakin contributed thirty-three pieces to the fair; the paintings were then auctioned in Sacramento. *The Sacramento Daily Record Union* assessed him as

> a landscape artist of widely recognized ability. His paintings in the fair speak for his artistic excellence. The collection includes landscapes, valley and mountain, American views, foreign studies, grapes, architectural and street views, rustic scenery, Wassatch and Sierra mountain views, Donner, Great Salt Lake and other studies. It is understood that the paintings will be sold with or without the frames. It is an exceptionally fine opportunity to secure some fine pictures.[3]

It is significant that the paintings were sold "with or without the frames," as nearly all of the paintings transferred from the State of California's Department of Finance to the Crocker Art Museum in 2006 were framed long after Deakin's death. Deakin

advocated standardized frame sizes in order to reduce the cost of preparing paintings for exhibition and sale; he even wrote an article on the subject for publication in New York.[4] At the 1886 sale he held at Easton & Eldridge, his paintings were sold without frames. For patrons who wanted them, Deakin selected frames by S. & G. Gump appropriate to each painting. It was up to the purchaser whether to buy one or not.[5]

The paintings originally held by the Department of Finance were a bequest of Deakin's younger daughter, Dorothy Deakin. Having adorned private offices for decades, these paintings have now been transferred to the Crocker for public benefit and enjoyment by a broad audience. For making this transfer a reality, the Crocker is extremely grateful to the State of California's Department of Finance, especially Stephen W. Kessler, then Chief Operating Officer; Molly Arnold, Chief Counsel; and Lorna Yee, Administrative Assistant. Gracious assistance was also provided by Muriel Johnson, Marcy Friedman, and Scott Heckes.

Deakin's frugality regarding framing meant that many of the paintings ultimately willed by his daughter to the California Department of Finance were not framed, as they were not intended to be sold. The period-appropriate frames enhancing these paintings today were acquired during the past year through the help of donors who funded their purchase as well as the conservation of the paintings themselves.[6] These generous donors include Gerald D. Gordon, Louise and Victor Graf, Nancy and Dennis Marks, Susana and Aj Watson, Melza and Ted Barr, Bobbi and Dick Nathanson, Thea Stidum, Nancy Woodward, Théa and Chuck Givens, Dr. and Mrs. Edward H. Boseker, Susan McClatchy, Martha and Roland Mace, Nikke Sosnick, and numerous other Crocker members. Linda Suskind, A.P.F. Master

Framemakers, and Karen and Jim Alkons, Northern California Art Conservators, respectively, performed the framing and conservation work. We also thank Dr. Oscar Lemer for giving thirty-nine Deakin drawings to the Crocker in 1978. Many of these appear in the exhibition and catalogue.

This project would not have been possible without the help of Alfred C. Harrison Jr. We thank him for his introductory essay and for the methodically compiled newspaper articles that he lent to the cause. His willingness to share information and early photographs, and to help secure loans for the show, is greatly appreciated.

John, Josh, and especially Joel Garzoli, of the Garzoli Gallery, provided access to signature Deakin paintings and their owners as well as images for reproduction. Peter M. Fairbanks and Elisabeth Peters of Montgomery Gallery provided direction and images. Edan Hughes's forty years of research on early California artists has made it possible to attempt projects like this, and his ready willingness to provide dates and investigate untapped sources is invaluable. Other archivists, historians, and art historians deserving acknowledgment include Julianne Burton-Carvajal, Beth Werling, Ellen Halteman, and previous scholars of Deakin's work—Donald C. Cutter, Ruth I. Mahood, Paul Mills, and, especially, Marjorie Dakin Arkelian. Particular thanks also go to Martin Arkelian and Margaret Dakin Lumley for their patient assistance in providing names, dates, and photographs from the family's archive. Dr. Robert Senkewicz and Dr. Doyce B. Nunis Jr., president and past president, respectively, of the Board of Trustees, Santa Barbara Mission Archive-Library, provided invaluable information and support. Photographers of Deakin paintings include Chris Berggren/Custom Image, Dean Burton, William B. Dewey, M. Lee Fatherree, and, especially, Crocker Art

Museum photographer Jesse Bravo, who produced the majority of the beautiful images that appear in this book.

Many individuals and corporations have provided images and lent their paintings, including Marjorie Dakin Arkelian through Martin Arkelian, Barbara and John Callander, Heidi and Ward Carey, Kathryn and Roger Carter, Warren Davis, Maria and Joseph Fazio, Abigail and William Gerdts, Perry and Martin J. Granoff, McKesson Corporation, Richard Pettler and Wanda Westberg, Bette and Stewart Schuster, and Mr. and Mrs. Fred Vierra. Curatorial assistance, images, and institutional loans were graciously provided by Anthony's Fine Art and Antiques; Julie Armistead, Hearst Art Gallery; Lynn Bremer, Santa Barbara Mission Archive-Library; Timothy Anglin Burgard, Sue Grinols, and Jane Glover, Fine Arts Museums of San Francisco; Linda Cooper, Shasta State Historical Park, Old Courthouse Museum; Jessie Dunn-Gilbert, North Point Gallery; Musée d'Orsay, Paris; Dr. Claire Perry, Cantor Arts Center; Smithsonian American Art Museum, Washington, D.C.; Joy Tahan, Oakland Museum of California; and Ann Wolfe, Nevada Museum of Art, Reno.

I gratefully acknowledge the staff of Pomegranate Communications in Petaluma, led by publisher Katie Burke, for their commitment to the project. Pomegranate contributors include editor James Donnelly and graphic designer Lynn Bell.

At the Crocker, director Lial A. Jones extended gracious direction and support, and assistant curator Diana Daniels provided immeasurable help and editorial expertise. Others contributing to the effort include Tom Arnautovic, William Breazeale, John Caswell, Kathleen Conaty, Mark Hebert, Karen Leslie, Patrick Minor, LeAnne Ruzzamenti, Patricia Beach Smith, Lisa Spivak, Lynn Upchurch, and Steve Wilson. Shyra McClure is particularly acknowledged for managing images and compiling the chronology of Deakin's life.

Finally, I thank Edwin Deakin for producing a body of work that is both beautiful and historically important. Although his paintings are widely appreciated, this is the first major exhibition and publication to truly feature the diversity of his production. Ninety years have elapsed since the last significant survey of Deakin's paintings appeared, hosted by the artist in his Berkeley studio. One hundred and twenty years have passed since his large showing took place in Sacramento, at the California State Fair.

Like those exhibitions, this show presents landscapes, still lifes, and architectural scenes from the American West and Europe, as well as the paintings of California missions for which Deakin is best known today. This range of genres, and the skillful consistency with which he worked in each of them, attest to Edwin Deakin's high level and breadth of artistic accomplishment—overlooked for far too long.

SCOTT A. SHIELDS
Chief Curator, Crocker Art Museum

1. "The Art Gallery," *Sacramento Daily Record Union,* Sept. 17, 1888.

2. "The Close of the Fair," *Sacramento Bee,* Sept. 18, 1886; "Fine Art Awards," *Sacramento Bee,* Sept. 22, 1887.

3. "Deakin Art Sale," *Sacramento Daily Record Union,* Sept. 14, 1888.

4. According to the *San Franciscan,* Deakin's articles on standardized framing "aroused an interest in the matter among Eastern artists." "The Artists," *San Franciscan,* Sept. 20, 1884.

5. *Catalogue of Oil Paintings,* Easton & Eldridge Auctioneers (San Francisco, sale held Nov. 10, 1886).

6. The paintings were framed in the 1960s with contemporary moldings that have recently been replaced.

PORTRAIT OF DEAKIN, 1876

J. H. Peters & Co., photographer.
Collection of Marjorie Dakin Arkelian

A NINETEENTH-CENTURY MAN
DEAKIN and the SAN FRANCISCO ART SCENE

Alfred C. Harrison Jr.

When English-born, self-trained artist Edwin Deakin arrived in San Francisco in the summer of 1870, he came to a city whose art environment was primed for a major step forward. During the 1850s and early 1860s, local artists found themselves in a culture that was in the primary stages of development, and they struggled to make ends meet, often living off portrait commissions or practical tasks such as designing letterheads and decorations for official documents. No art institutions had been created, and artists had to use their studios as exhibition spaces and sales rooms, since the only public art galleries were dark and cramped corners of art supply stores.

In 1865, the California Art Union was founded to promote local art culture. Modeled after the American Art Union, this institution created a lottery for its subscribers awarding works of art purchased from local painters to lucky winners. Although it failed after just one year, the Art Union publicized the works of San Francisco painters, and newspapers started to cover the art scene with greater attention. As fortunes were made as a result of the Gold Rush, the Comstock silver mines bonanza, and the establishment of the Central Pacific Railroad, huge mansions were built in San Francisco toward the end of the 1860s. Enamored of the place where success had been achieved in such a short time, many new tycoons wanted to decorate their parlors with paintings depicting the beauty of California scenery.

Landscape art, long favored in the East, became the most popular genre in San Francisco.[1]

In 1869, a fancy new commercial art gallery opened at the frame and art supply store Snow and Roos. With skylights in the daytime and gaslights at night, this exhibition space gave local artists an opportunity to show their works to good advantage and sell them to collectors.[2] Prosperity was at hand for local painters, and many of them quickly made enough money to underwrite extended trips to Europe for further study and training. Young painters on the West Coast knew that they could never achieve full professional status without acquainting themselves with the cultural centers of the art world.

By 1870, the roster of talented young painters in San Francisco had been depleted by this process. First Virgil Williams and Thomas Hill, and later William Keith, Norton Bush, and William Marple, left town, creating an opportunity for young and energetic new painters like Edwin Deakin to establish themselves.

In 1871, San Francisco painters and leading businessmen founded the San Francisco Art Association to hold exhibitions and give a focus to local art activities. The exhibitions' openings became important social events, attended by all prosperous Bay Area residents dressed up in their finest clothes. The arrival of Albert Bierstadt in town boosted the fledgling organization's prosperity and reputation—Bierstadt's fame had spread beyond

the United States to England and the Continent as a result of his huge paintings of western scenery, including views of Yosemite Valley based on his 1863 visit. Bierstadt would spend most of the next two years as a San Francisco painter, and his works, selling at high prices to local collectors, became the target of emulation by other landscape painters, including Edwin Deakin.

The energy and ferment of the San Francisco art world led key painters of the 1860s to hurry back to the West Coast to test the waters. Thomas Hill and William Keith returned from Boston in 1872 and joined in the competition with Bierstadt to secure commissions for large paintings of sublime California subjects like Yosemite and Mount Shasta. Mountain grandeur had been a staple of Hudson River school landscapes in the East, rising to a high point with the exhibition during the 1850s of Frederic Church's depictions of South American peaks.

The English romantic poets and American transcendentalist writers popularized the notion that contemplation of unspoiled nature was a therapeutic experience for the city dweller, and the idea became ingrained in nineteenth-century American culture. Landscape art became a way for urban residents to be reminded of the morally healthy great outdoors. One could revel in Shasta's splendor in the comfort of the drawing room, sparing oneself the long and uncomfortable stagecoach ride to the mountain itself.

While landscape painters depicted nature in a way that emphasized its potential for embodying transcendental metaphors, they were also supposed to create a credible image of a real place. Gross exaggerations of topography or meteorology were not tolerated, and by often ignoring this requirement, Albert Bierstadt saw his reputation diminished. What constituted an excessive manipulation of natural effects was a subjec-

tive judgment, and Deakin crossed the line in the opinion of several San Francisco critics, who attacked the unnatural appearance of his landscapes.[3]

Painting the manifold beauties of California scenery during the 1870s brought a comfortable income to Deakin, Hill, Keith, and the other San Francisco–based landscape painters. Most of these artists followed the same marketing strategy. They would send major works to Art Association exhibitions, where they would be reviewed in the newspapers. Often the paintings were sold directly out of this venue. Other paintings would be consigned to Snow and Roos or the many other commercial art galleries that came into existence in the 1870s—Morris, Schwab, M. D. Nile, Currier and Winter, and several others.

Deakin exhibited his paintings with various dealers, not signing an exclusive contract with any of them. Often he was able to get his major works placed in the gallery's windows, which was more likely to get them noticed in the newspapers. If the paintings did not sell through the art dealers, Deakin would take them back and organize an auction of his own paintings. This was a commonplace business practice among nineteenth-century American painters—in New York, Boston, and Chicago as well as San Francisco.[4] The danger in this way of doing business resided in the disparity between the art gallery's retail prices and the lower prices often obtained at auction, which undercut the art dealer's ability to sell paintings. Nevertheless, Hill, Keith, Norton Bush, and most other West Coast painters would occasionally sell their works at auction.

By 1875, San Francisco's population had increased to about 150,000 people. It was now a real city, but still too small to support the growing number of landscape painters drawn there

by its reputation for generous art patronage and its proximity to the scenic wonders of California. Only a small percentage of the population could afford to buy paintings and only a small percentage of the qualified cared enough about owning original art to do so. Dozens of panoramic views of Yosemite Valley became available during the 1870s, and paintings of other popular sites like Mount Shasta and Lake Tahoe glutted the market. The search was on for new, less hackneyed scenes. Albert Bierstadt led the way in exploring the mountains for new subjects, traveling to Inyo County in 1872 and 1873 to capture the Southern Sierra range from the east. Deakin also became known for his adventurous high country treks in the Lake Tahoe area and became the first artist to paint the picturesque Fallen Leaf Lake near the southwest corner of Tahoe. He discovered other fresh sites like Cascade Falls.[5]

After about 1870 when an artist's field studies were elevated to the status of paintings worthy to be exhibited and sold, a prolific and indefatigable artist like Deakin ran the risk of flooding the California market with too many of his works. When Norton Bush's 1885 auction sale found few buyers, an observer commented, "Nearly every one in town who buys pictures already has something of Bush's."[6] Toward the end of the 1870s, Deakin was almost in that position himself. This peril was augmented by a gradual movement in the market away from topographically specific, carefully detailed scenes in the enhanced realism of the Hudson River school aesthetic in favor of the dark, spiritually charged generic views of the French Barbizon painters. This shift in fashion, strongly under way in New York, Boston, and Chicago by the early 1880s, was slow to take hold in California, whose mountains were such inspiring subjects for

landscape. Painters like Deakin, Thomas Hill, and Frederick Schafer were able to find buyers for sublime landscapes well into the early twentieth century, long after this subject matter had been shunned by eastern artists.

Almost every painter who tasted success on the West Coast in the last third of the nineteenth century felt the need to go abroad and acquaint himself with what was happening in cities like London, Paris, and Munich. In addition to affording the painter a more expansive view of art than could be found in San Francisco, the grand tour—especially if one's work was accepted for exhibition at the Paris Salon—was a way of legitimizing one's claim to being more than a minor regional practitioner. Success at the Salon led to higher prices and better sales on the home front. Another benefit of foreign travel was the broadening of subject matter available to the artist. Mount Blanc, Lake Geneva, and other such sites supplemented Deakin's repertoire of Mount Shasta and Lake Tahoe scenes, and Notre Dame Cathedral, ancient English inns, the church at Stoke Poges, and other storied destinations were added to Deakin's views of the romantic missions of early California.

From his first summer in San Francisco, Deakin was attracted to architectural subjects, especially the ruins of the Franciscan missions, and perhaps he should be considered the first professional artist (as opposed to illustrator) to portray them. He painted several missions in the 1870s and returned to this subject again in the 1880s and 1890s as a way of diversifying his output away from increasingly hard-to-sell landscapes. The publication of Helen Hunt Jackson's best-selling novel, *Ramona,* in 1884 stimulated interest in mission life and increased the popularity of mission paintings.

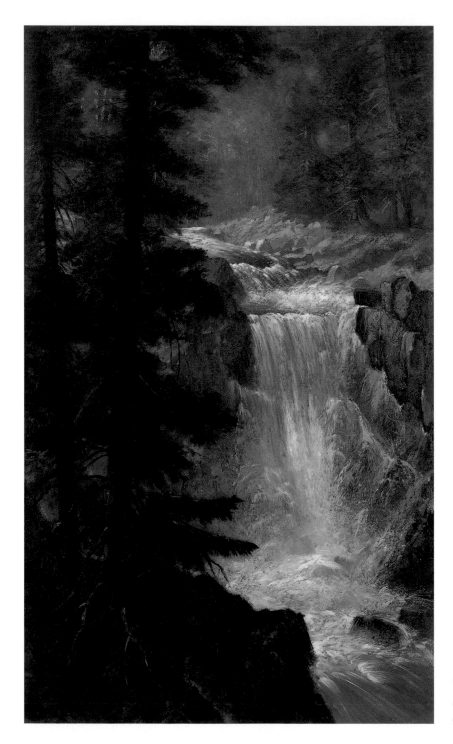

CASCADE FALLS NEAR LAKE TAHOE, 1877

Oil on canvas, 40¹/₄ x 24¹/₄ in.

Collection of Mr. and Mrs. Fred Vierra

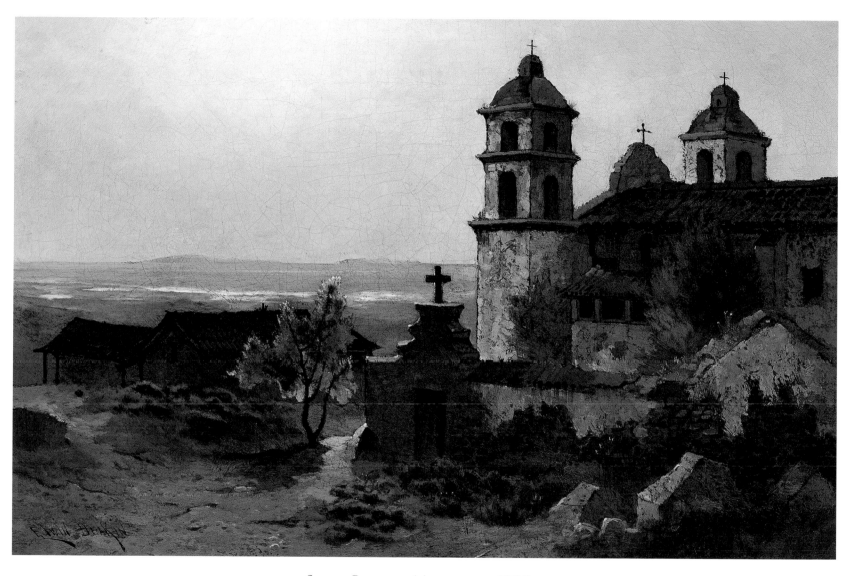

SANTA BARBARA MISSION, c. 1880s

Oil on canvas, 16 x 24 in. Private collection, courtesy of Garzoli Gallery

In about 1880, the San Francisco art market went into a steep retreat, and many established painters, including Thomas Hill and William Keith, journeyed eastward to set up studios in New York and Boston. Between 1881 and 1884, Deakin tried his luck in various cities—Cincinnati, Denver, Salt Lake City—before coming back to San Francisco. Diversification away from landscape became widespread among California painters. Fearing that he could no longer make a living as a landscape painter, the middle-aged William Keith traveled to Munich in 1884 to learn how to paint portraits. Back in California, he accepted portrait commissions and taught a class of students—a route that many San Francisco painters of the 1880s and 1890s also followed. Raymond D. Yelland, L. P. Latimer, and Arthur Mathews were among the more prominent artists who supported themselves by teaching.

As pure landscapes lost favor, some painters turned to still life. The important Hudson River school artist Martin Johnson Heade is today the best known of several landscape painters who diversified into still life. John Ross Key, who had painted Lake Tahoe and Yosemite in 1869 and 1870 before establishing himself in Boston and later in Chicago, became respected for his flower paintings. In California, landscape painter Ferdinand Richardt also embraced still life in his later career. Emil Carlsen began his career painting landscapes in the Hudson River school mode, but during his California years from 1887 to 1891 was largely a painter of kitchen still-life paintings reminiscent of J-B. S. Chardin. Starting in the early 1880s, Deakin branched out into this area under the tutelage of his close friend Samuel Marsden Brookes, the only San Francisco painter who had made a specialty of still life. In a remarkably

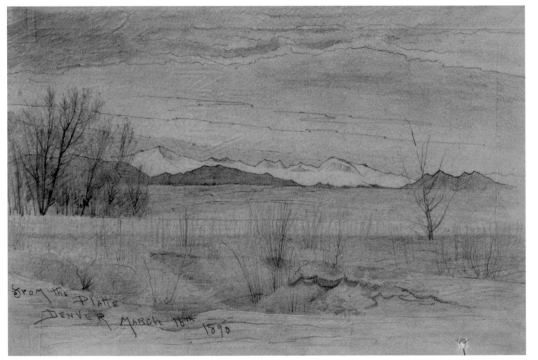

FROM THE PLATTE, DENVER, MARCH 16, 1890

Graphite on paper, 6 x 9 in. Crocker Art Museum, gift of Dr. Oscar Lemer, conserved with funds provided by Susana and Aj Watson

CITY CREEK CANYON, SALT LAKE CITY, n.d.

Graphite on paper, 13 x 9 1/2 in. Crocker Art Museum, gift of
Dr. Oscar Lemer, conserved with funds provided by Susana and Aj Watson

short time, Deakin became adept at painting grape clusters posed against mellow stucco walls and tabletop bowls of plums in the Peale tradition. The rise in popularity of aesthetic home decoration toward the end of the century spurred on this increased interest in still life.

Paintings of Yosemite and other mountain subjects by Hill, Schafer, Deakin, and others were still marketable to people who did not care about changing fashions in landscape. But as early as 1885, the art critic for the *San Francisco Chronicle* concluded that "the day for painting Yosemite pictures is over," and while observing that Hill was still painting them, declared that they should be considered "posthumous" works.[7]

After George Inness, then at the pinnacle of American landscape painting, visited San Francisco in 1891, somber, brooding paintings of oak trees in the Barbizon style became the fashionable and profitable approach to landscape. William Keith's late career exemplifies the supremacy of this "tonalist" strategy, as the dozens of dark sunsets he churned out found eager buyers, especially among those with high cultural pretensions like the railroad baron E. H. Harriman. Deakin disliked this way of painting in which subjects, insignificant in themselves, afforded the artist greater latitude for self-expression.[8] Throughout his career, he considered the subjects of his paintings more important than his treatment of them. By the 1890s, the impressionist movement, with its bright colors and informal compositions, had penetrated the landscape styles of eastern painters like William Merritt Chase and Childe Hassam but did not take root in Northern California until the first decade of the twentieth century. Deakin probably agreed with William Keith's dismissal of the impressionist approach to art as lacking sufficient spirituality.

Edwin Deakin was essentially a nineteenth-century man. He shared John Ruskin's love for nature and his disdain for modern life in the age of the Industrial Revolution. Deakin's paintings demonstrate a reverence for pristine nature before European encroachment. When a human presence appears in his landscapes, it is usually in the form of modest Indian camps, evoking an Edenic time before the advent of tourists and logging crews. Deakin's architectural studies look back to the simpler era of pure religious faith—lamenting its decline à la Matthew Arnold in depictions of missions in ruins or celebrating its history in portrayals of Notre Dame and Westminster Abbey. Deakin's still-life paintings ennoble their humble subjects by bathing them in beautiful light. Nobility, spirituality, and the charm that time bestows on picturesque sites were the qualities that Deakin sought to express in his paintings. He has left us a strong legacy.

1. Sources on nineteenth-century San Francisco art include William H. Gerdts, "The Pacific, Northern California," in *Art across America,* vol. 3 (New York, Abbeville Press, 1990), 223–291; Brigitta Hjalmarson, *Artful Players: Artistic Life in Early San Francisco* (Los Angeles: Balcony Press, 1999); and North Point Gallery, San Francisco, clippings archive.

2. "Local Art Items," *San Francisco Bulletin,* Apr. 10, 1869, p. 5; "Opening of a New Art Gallery," *Alta California,* Apr. 11, 1869, p. 1; "The New Art Gallery," *San Francisco Bulletin,* Apr. 13, 1869, p. 3; "The New Art Gallery," *San Francisco Bulletin,* Apr. 18, 1869, p.3.

3. E.g., "Art Notes," *Overland Monthly,* Dec. 1874, p. 574.

4. Take, for example, the case of John Ross Key: during his San Francisco period, he held a sale of his own paintings on Mar. 19, 1870, and again on Nov. 4, 1870; during his Boston period, on Oct. 29, 1875, Dec. 8 and 9, 1876, May 9, 10, 1877, Feb. 6, 7, 1878, May 18, 19, 1880; during his Chicago period, on Apr. 26 and 27, 1881, Jan. 25, 27, 28, 1884, and Apr. 24, 25, 1890.

5. See "Brush and Pencil," *San Francisco Chronicle,* June 22, 1874, p. 3, and "Art Notes," *Illustrated Press* [San Francisco], Aug. 1874, n.p.

6. "The Artists," *San Franciscan,* Feb. 21, 1885, p. 13.

7. "Art Notes," *San Francisco Chronicle,* May 31, 1885, p. 6.

8. See "Art in Paris," *San Francisco Chronicle,* July 7, 1879, p. 3.

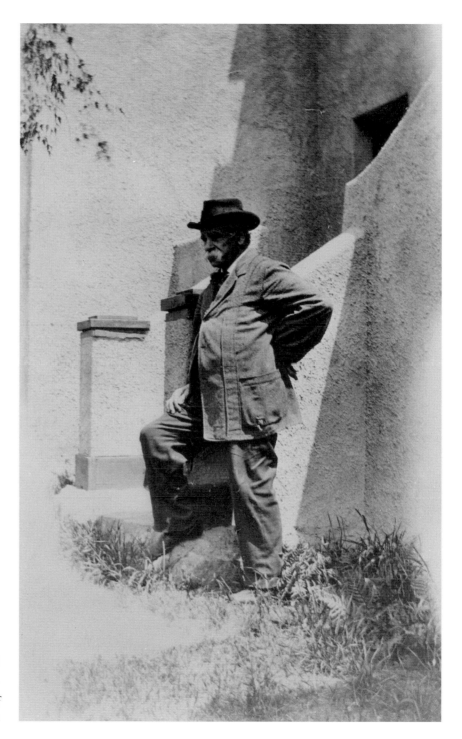

SAN GABRIEL MISSION, n.d.

Oil on canvas, 22 3/4 x 35 1/2 in. Crocker Art Museum, gift of Gerald D. Gordon

CALIFORNIA PAINTER *of the* PICTURESQUE

Scott A. Shields

Edwin Deakin's paintings represent an aesthetic evolution in California art, a shift from the sublime to the picturesque. His landscapes, still lifes, and, most famously, historic buildings—particularly California's Spanish missions—stem from a quieter tradition than the art of the Hudson River school, the primary inspiration for California's most noteworthy painters until the mid-1870s.

Before Deakin, most regional landscapists, following the example of Thomas Hill and Albert Bierstadt, aimed to proclaim and glorify their own place in America by depicting a paradise (Yosemite, the Sierra) of grandeur and drama. Their paintings brought the idea of manifest destiny to life and the wild glory of California to audiences worldwide.

Artists of the late nineteenth century, like Deakin, were less concerned with overtly expansionist statements. American landscape painting moved away from Ruskin's "truth to nature" and toward Whistler's "art for art's sake." Freer paint handling and individual expression displaced tight literalism and leaf-by-leaf detail. Accompanying this retreat from literalism was a shift from a boldly panoramic depiction of nature to a more intimate view, in human scale. A contemporary writer observed of Deakin that he had "the power to make his revelations . . . appreciable to all, the spectator feels them; he is impressed with a reality in the painting which appeals to the soul rather than to the judgment

or the eye itself. It is not enough to state that the painting[s] are true to nature; they are exponents of nature."[1]

During the final quarter of the century, the American West—and California in particular—became largely settled. The transcontinental railroad had linked the Golden State with the rest of the country in 1869. Now, confident of California's importance in the broader context of the nation, artists took on less grandly iconic subjects: live oaks and redwoods, golden hillsides, and miles of uninterrupted coast. Still lifes of California's agricultural bounty became popular; architectural views reflected the state's diverse cultures and rich history, acknowledged by Deakin in his paintings of San Francisco's Chinatown and California's missions. Inclination and circumstance moved Deakin to depict magnificent vistas as well, especially in the early 1870s, at the outset of his career. But natural grandeur increasingly gave way to other subject matter.

Contemporaries who likewise found diminishing interest in California's sublimity included Jules Tavernier and William Keith. Tavernier translated the Barbizon style of his native France into poetic, moody views of coastlines, wooded glens, and meadows; he had little interest in mountain majesty. Having accepted a much-needed commission to paint a Yosemite scene, Tavernier is said to have remarked, "This thing shows everything and tells nothing! It drives me mad to work on it!"[2] Like Deakin, Keith

started out painting California in the Hudson River school style, but he eventually arrived at deeply personal, profoundly spiritual paintings of wooded groves with tranquil ponds and grazing livestock. "When I began to paint," Keith explained, "I could not get mountains high enough nor sunsets gorgeous enough for my brush and colors. After a considerable number of years' experience, I am contented with very slight material—a clump of trees, a hillside and sky; I find these hard enough, and varied enough to express any feeling I may have about them."[3]

Other painters, such as William Marple, Raymond Dabb Yelland, and Gideon Jacques Denny, worked in a style aptly described as California luminism, a regional counterpart to the quiet, diffusely lit coastal and inland scenes long popular in the East. In their evocation of divinity, these paintings expressed a reverence for nature that correlated with the transcendentalist writings of Emerson and Thoreau. By the turn of the century, Evelyn McCormick, Theodore Wores, and other Northern California artists had embraced the higher-keyed colors and the outdoor light of impressionism, depicting flower-covered hillsides and views of the desert and sea. In all of these styles, artists acknowledged a human presence, but one in harmony with, or inconsequential to, nature.

While Deakin's works could have much in common with the atmospheric poetry of the Barbizon style, his light frequently captured the spiritual qualities sought by California luminists, and although his rich colors sometimes reflected the influence of impressionism, his motivations were different. Deakin chose to depart from tradition by exploring what may best be termed a Californian—and often in his case a European—picturesque. Other California painters, notably John Ross Key, William

Hahn, and Marple, produced works that fit this description, but Deakin ultimately specialized in the style.

For the English-born Deakin, the "picturesque" was as readily found in the American West as it was in Europe, and he painted both American and European subjects throughout his career. As one writer explained: "Love of the old, the picturesque, and the romantic came to Mr. Deakin in his earliest youth, when, as a boy in England, he wandered among ruins of churches and castles, dreaming of valorous deeds of bygone heroes, and, in fancy, weaving stories and pictures to fit the hallowed scenes."[4]

The picturesque became popular in eighteenth-century England as a reaction to the formality of classicism. Picturesque imagery represented rural people and customs, exotic cultures, architecture in ruins, and quiet, "imperfect" depictions of nature: weathered rocks and cliffs, fallen trees, and meandering creeks. In composition and technique, painters of the picturesque favored asymmetry, the unexpected, and the painterly over balance, stability, and an enamel-like finish. In both subject and style, these paintings led the way to later movements, such as romanticism. Nineteenth-century critics frequently described Deakin's work as picturesque and also called it "romantic," for his paintings, especially of architectural subjects, alluded to a sense of nostalgia and time past.

The evidence of humanity, although not the immediate presence of humans, plays a pivotal role in Deakin's paintings. His farms are carefully cultivated; his views of nature are life-scaled and include tangible signs of human endeavor. Architecture frequently subordinates the landscape. A critic described Deakin's studio as "full of beautiful paintings, foreign and native landscapes and print pictures. There are woodland scenes, flocks and

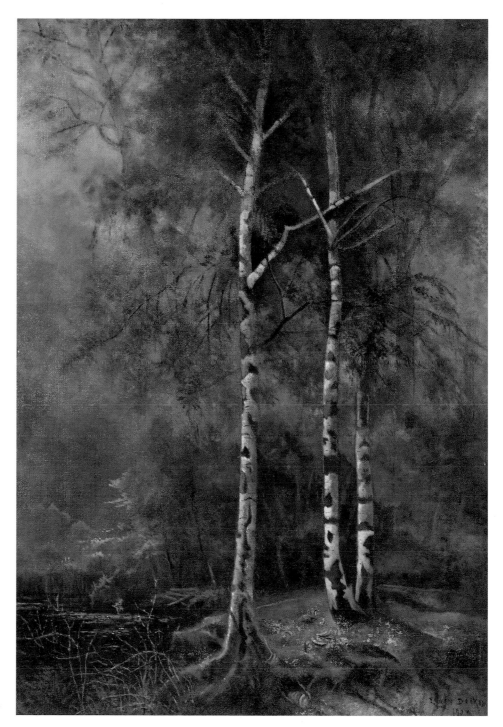

MYSTERY [sketches made at Meudon
& Clamart near Paris], 1904

Oil on canvas, 42¹/2 x 28¹/2 in. Crocker Art Museum,
long-term loan from the California Department of Finance,
conserved with funds provided by Louise and Victor Graf

their shepherds, old inns, romantic chateaux, rustic bridges and mountain scenes with lakes of clear crystal water and picturesque old mills."[5]

Another observed that

> There is an original style in Deakin's pictures—a mellow tone—a peaceful, pastoral sentiment pervading his landscapes; very restful and pleasing. His pictures have a soothing effect, very grateful to the jaded mind and tired brain; . . . such old homelike, gable roofed farm-houses as Deakin puts upon the canvas; such ivy-clad church towers, and venerable porches; such shady, inviting lanes and trysting-places, and mysterious turns in the road, and gaps in the old hawthorn-hedge—all so suggestive to long slumbering memories, recalling scenes of everybody's youth, now sad, now sweet by turns, in passing retrospective.
>
> With nothing dramatic, nothing startling or exciting, Deakin's pictures are . . . pleasing to the last; their very absence of pretence, their best attraction.[6]

DEAKIN the INDEFATIGABLE

The third of seven children, Edwin Deakin was born in Sheffield in 1838.[7] His father, Robert, was from a family of cutlery manufacturers and worked as a bookkeeper; he would open a hardware business in Chicago.[8] His mother, Louisa Holroyd Williams Deakin, was born in Montreal, of Welsh descent.[9] In 1850 the Deakins moved to Wolverhampton, and the twelve-year-old Edwin became an apprentice at an establishment specializing in japanning furniture, learning to paint flowers, landscapes, and other decorative designs. Except for this experience, and private study from books and gallery visits, he remained largely self-taught.[10]

When the family moved to Chicago in 1856, Edwin Deakin brought with him many watercolor and pencil sketches, aiming to pursue a career in art. Finding his options limited in the Midwest, he took a job hand-coloring photographs; he also worked as a "case-maker." In 1865, he married a charming Englishwoman, Isabel "Belle" Fox (1846–1924), in Chicago. Deakin had three children with Isabel.[11]

In 1867, Deakin stopped coloring photographs, "studied art from the great teacher, Nature," and began painting.[12] Toward the end of the decade, he exhibited a painting publicly for the first time at the Crosby Art Gallery; this early effort, an architectural subject of an old English tavern, set the tone for much of his later work. Shortly thereafter, he became a member of the Chicago Academy of Design.

Deakin visited San Francisco in the summer and fall of 1870, a trip marked by his participation in local exhibitions. *The Golden City*'s critic reported that

> Mr. Edwin Deakin, who, for all we know may be a genuine "deacon," as he is a new apostle among the brethren on this coast, has given a sample of his powers in a picture of 'Ravenswood'. . . . A wood scene is always troublesome, and rarely satisfactory. Yet, some of the foliage is cleverly handled—the drawing correct, and the color in passages pretty and delicate. But there is too much blue in the distance; and a certain affectation of style, which imparts to the work an artificial air that no excellences can overbalance.[13]

Such criticisms were difficult for Deakin, who held a high opinion of his own work and was easily offended. The *San Francisco News Letter and California Advertiser* would later sum up his irascible personality: "This gentleman is proverbially the most sensitive of all the artists regarding the criticisms which appear from time to time upon his works. He seems to forget that an artist and his pictures are decidedly separable, that the one has no connection whatever with the other, so far as criticism is concerned." The reporter recounted Deakin's explosive reaction to a critic's disparaging remarks. Deakin "made a passionate onslaught upon him in the public Art Gallery"; had mutual friends not intervened, "bodily violence would have no doubt been done him."[14]

In keeping with his formidable nature, Deakin's appearance was "somber" and "intellectual-looking," enhanced by piercing dark eyes, wavy black hair, and a bushy moustache. According to contemporaries, he was unassuming but quite formal in demeanor. Deakin disdained vulgarity and rudeness and became "hostile almost to aggressiveness against everything vicious and pretentious."[15] Still, his many friends found his company congenial. "Art?" he joked. "Gracious heavens, don't ask me! . . . I defy anyone to tell what art is. I don't profess to know anything about it myself."[16]

Despite his sensitive temperament, Deakin was kind at heart, generous, and quick to help emerging artists, taking the view that "art is free as water."[17] He was also ready to come to the aid of his colleagues. After the painter Fortunato Arriola drowned at sea, Deakin and the painter-engraver Pascal Loomis were charged with soliciting artists and galleries for paintings to be sold to benefit Arriola's survivors. With donations from

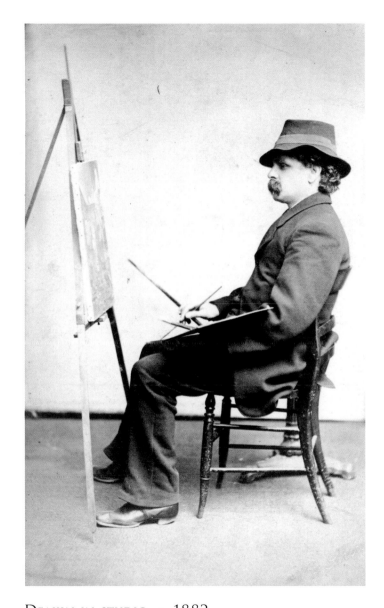

DEAKIN IN STUDIO, c. 1882

William Shew, photographer.
Courtesy North Point Gallery, San Francisco

almost all of San Francisco's major artists, the fundraiser was highly successful. Deakin himself contributed *A View of the Truckee,* which sold for $50. Another Deakin painting, *The Sign of the Gate,* was contributed by San Francisco mayor William Alvord from his personal collection.[18] Later, when Ernest Narjot was blinded while painting, Deakin again contributed a piece to benefit a fellow artist.[19]

Once "Deakin the indefatigable," as the *News Letter* called him, settled on a project, he pursued it seriously.[20] A fierce-looking sign on his studio door, "Engaged till 4 O'clock," discouraged all visitors except those who knew the signal knock, so that he could work uninterrupted from the day's first light. He combined single-minded focus with a painting technique that was quick, sure, and often lightning fast. "If Church and Moran could but approach Mr. Deakin in rapidity of execution," declared the *News Letter,* "they would, in a few years, rival the Bonanza Kings in wealth."[21]

COURTING NATURE

Landscape Paintings

In 1871, Deakin and his family returned to Chicago, where his daughter Edna was born. In October, the great Chicago fire consumed much of the city, including the family's hardware business and all but six of Deakin's paintings. The loss sent him back to San Francisco. Painting in a studio at 611 Clay Street, Deakin produced landscapes of Illinois, the San Francisco area (particularly the East Bay), and vistas captured en route to and from San Francisco, the latter "marked by a vigor of treatment far from common."[22] He exhibited these paintings at the Kearny Street

gallery of M. D. Nile in May 1872, and, as a member of the recently founded San Francisco Art Association, at its inaugural show in June.

In the summer of 1872, Deakin returned to Chicago to persuade his parents and siblings to move to California.[23] While there, he produced scenes of the "tangled wildwoods" of Illinois and views of the local landscape, including a large painting of Lake Michigan. As on previous journeys, he sketched the scenery he encountered along the Central Pacific Railroad route, later turning the drawings into paintings. These included views of the Wasatch Mountains in Utah, the Humboldt River and Humboldt Mountains in Nevada, and scenes from the Truckee River, near Reno Valley.

Deakin sent *The Wasatch Mountains, Utah* east for exhibition at the Milwaukee Art Gallery and showed other recent works in San Francisco, receiving acclaim at both venues. According to a reviewer from the *San Francisco Evening Post,* the pictures were "distinguished by closeness to nature, the artist inclining to pre-Raphaelitism; imitating, though not with servile exactness, the character of the subject chosen for his pencil."[24] In October Deakin left the city again to sketch around Lake Tahoe, and the following month found him "courting nature" in Yosemite with colleagues Benoni Irwin, Thomas Ross, and Hiram Reynolds Bloomer. The latter trip produced one of his most successful paintings to date, a painting of Yosemite Falls.[25] The *Evening Post* remarked, "In landscape, Edwin Deakin exhibits talent of no common order. He is represented by but one picture in the Gallery, but it is one which shows his talent to advantage. It is a view from that grand theater of nature, Yosemite, and shows the lower fall surrounded by its attendant wonders."[26]

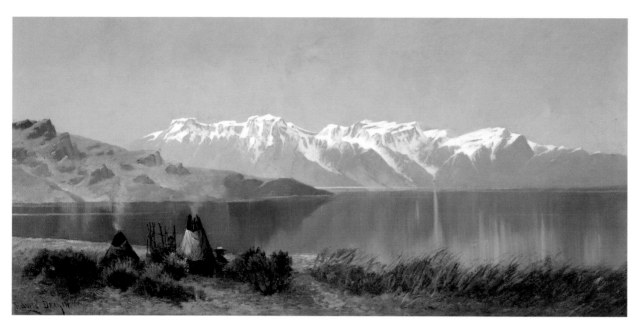

INDIAN ENCAMPMENT, n.d.

Oil on canvas, 17¹/₂ x 35¹/₂ in. Long-term loan to the Nevada Museum of Art, Reno

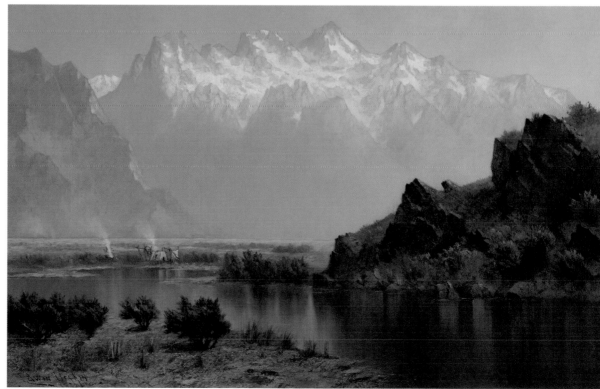

HUMBOLDT MOUNTAINS, RUBY RANGE, NEVADA, 1882

Oil on canvas, 24¹/₂ x 36 in. Crocker Art Museum, gift of Dr. and Mrs. Herzl and Betty Friedlander

Early paintings such as this one typically portrayed pure landscape scenes, although Deakin found his signature subject in the Spanish-era missions almost immediately after arriving in California. In 1870, he had exhibited a painting of Mission Dolores at the gallery of Snow and Roos. Although he produced street scenes and "portraits" of buildings from the outset of his career, architectural scenes did not become a signature genre until 1880, and mission imagery did not occupy his primary attention until very late in the century.

In Deakin's early work, architecture was typically subordinate to the landscape. Tranquil glens, intimate or panoramic vistas, and farming scenes were "notable for excellent points of design; some . . . being quite poetical and showing good brush work."[27] Agricultural subjects were of particular interest to him, especially images of farming in the Livermore Valley, which he depicted a number of times in the early 1870s. Deakin was also known for his ability to capture water, and many of his paintings include a pond or lake to showcase his technique. One reporter called him an "amphibious painter . . . at home in wood and water scenes."[28]

In the spring of 1873, Deakin was industriously at work in San Francisco. His productions then included a "mellow representation" of the Rocky Mountains at the source of the North Platte—a view of distant snow-capped summits. He also finished a view of Mission Dolores, a street scene of old London, and a pair of small, quiet studies depicting Lake Tahoe and the Truckee

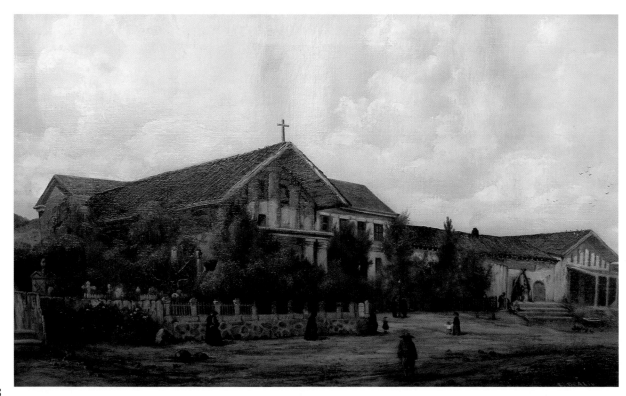

MISSION DOLORES
AND THE MANSION HOUSE,
SAN FRANCISCO, CAL,
1870

Oil on canvas, 26 x 42 in.
Courtesy Vintage Bank Antiques

Meadows, exhibiting them in March at the gallery of Morris, Schwab & Co., and a view of Donner Lake especially for display at the Bohemian Club.[29]

Founded in 1872, the Bohemian Club was a place where artists, writers, and the like could mingle with colleagues and with San Francisco's wealthy elite. Deakin joined in 1873. That same year, he also joined the Graphic Club, a group of San Francisco artists who came together to sketch.

In addition to the sales that he made through the Bohemian Club, the San Francisco Art Association, and commercial galleries, Deakin frequently held auctions of his work. He did so to reduce inventory and, of course, to generate income, often selling through H. M. Newhall & Co. Newspaper advertisements touted "ELEGANT OIL PAINTINGS, All careful studies, highly finished and handsomely framed in gold frames. Large, Medium and Cabinet Pictures of California, Oregon and Eastern Scenery."[30]

At his first major sale, held in the spring of 1873, Deakin hoped to sell fifty-one pictures, mostly landscapes and other studies from nature. More than half of the paintings were of California scenery. Out-of-state subjects showcased Deakin's travels and included the Green River in Wyoming, the Mississippi River, the Wasatch Mountains of Utah, Lake Michigan, and views of Indiana, Illinois, and New York. There was even a selection of European scenes drawn from his early sketches: landscapes, villages, churches, and castles from Antwerp, Strasburg, Staffordshire, and London.[31] The pieces were offered without reserve, and on the whole, the sale was a success. Bidding was spirited, attendance strong, and prices, although perhaps not quite what Deakin would have hoped, "sufficiently substantial" to convince the artist that his work was appreciated.[32]

The sale helped to solidify Deakin's reputation within the community. Working from his studio on Montgomery Street,

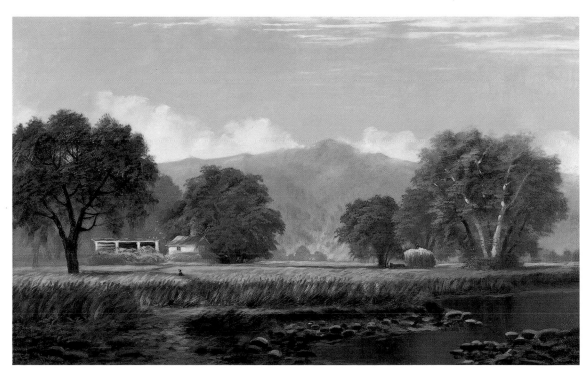

HARVESTING, LIVERMORE VALLEY, 1874

Oil on canvas, 16⅛ x 26⅛ in.
Collection of Dr. and Mrs. John Callander

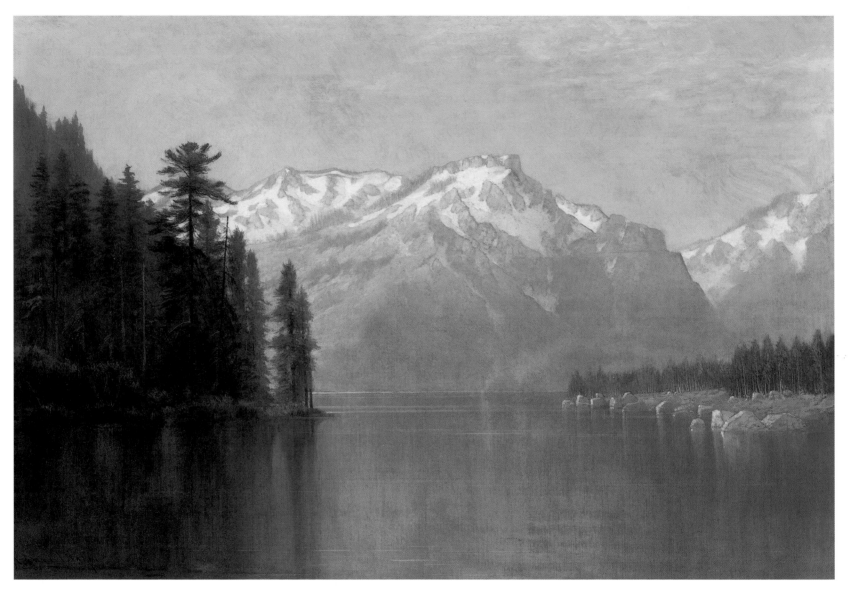

DONNER LAKE, CALIFORNIA, n.d.

Oil on canvas, 24¹/₈ x 36¹/₈ in. Collection of Perry and Martin J. Granoff

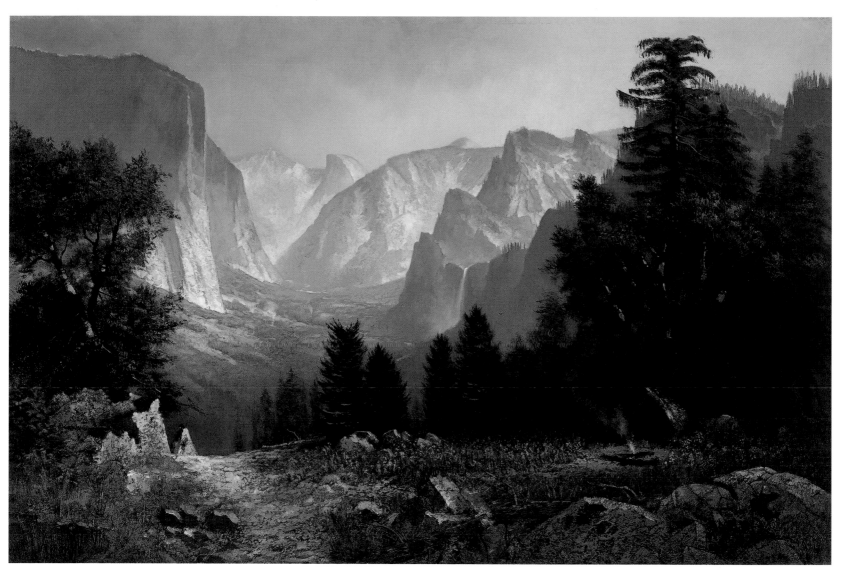

YOSEMITE VALLEY, n.d.

Oil on canvas, 24 x 36 in. Collection of Roger and Kathryn Carter

he began to advertise himself as a painter of landscapes and architectural scenes of the American West and Europe. In the window of Hastings & Co., he exhibited *Alameda Creek,* notable for its beautiful water; at the San Francisco Art Association galleries he showed *An Old English Inn;* at his studio he displayed *An English Church Porch* and an unfinished painting of the Wasatch Mountains.

In September 1873, Deakin embarked upon a sketching tour of Lake Tahoe, and that October he explored Cascade Lake and the Truckee River. These trips brought forth fifty-five oil studies, most derived from the areas around Mount Tallac and Lake Tahoe. Working outdoors, he made oil sketches on canvas and on heavy Winsor & Newton paper in preparation for his larger finished works. Deakin almost never used photographs, but he did work from his own color-annotated drawings. Used singly or in combination, often gridded for transfer, these served as the basis for large studio compositions. "He uses some of his sketches as the pen and scissors man his paragraphs," explained a *San Francisco Chronicle* reporter. "That is, he composes his larger pictures from them, and his pencil scraps of characteristic groups of mountain peaks. He has a large scrap-book full of them."[33]

Because plein-air work was still relatively unusual among California artists, at least early in Deakin's career, the practice—and the "truthfulness" of the results—drew notice from the press. "The sketches," commented one reporter, were "all made in the open air so that the details are all truthfully shown."[34] Another reported, "As sketches of the scenes were made on the spot by Deakin, they are of course truthful in all their details, and the value of the paintings is greatly enhanced in consequence."[35]

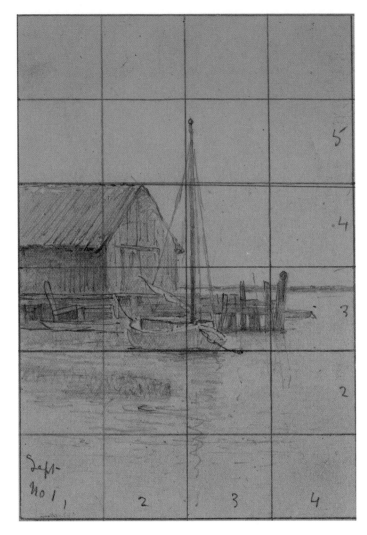

DOCK SCENE SEPTEMBER [preliminary sketch for THE ARTIST'S SKETCHING GROUND, ALAMEDA], c. 1881

Graphite on paper, 6 x 4 in. Crocker Art Museum, gift of Dr. Oscar Lemer, conserved with funds provided by Susana and Aj Watson

Many critics and patrons found the oil sketches appropriate for display just as they were. These small "cabinet pictures" found a ready audience among collectors with less money or who found Deakin's grander works to be "out of place in low, unpretentious rooms."[36] The *News Letter* explained:

> Deakin's sketches embrace a great variety—daylight, sundown, moonlight, and storm—and are full of truth to nature. They form a very pleasing little exhibition by themselves, and many of them, noticeably those of Emerald Bay and Falling Leaf Lake, are excellent subjects for large pictures. . . . When we say that these studies are in some

respects superior to the same artist's finished pictures, we say nothing derogatory to the latter. Sketches made entirely out of doors with Nature *en face* are sure to possess a freshness, vigor, and truth rarely attainable by studio work.[37]

By the end of the year, Deakin had produced several larger, finished paintings from the sketches made during his Tahoe trip. These included a view of a promontory extending into Lake Tahoe (the proposed site of the Lick Observatory), a scene of *Falling [Fallen] Leaf Lake,* and a large painting of *Job's Peak, Lake Tahoe.*[38] Other works depicting the region followed; many were sold at auction in February 1874.

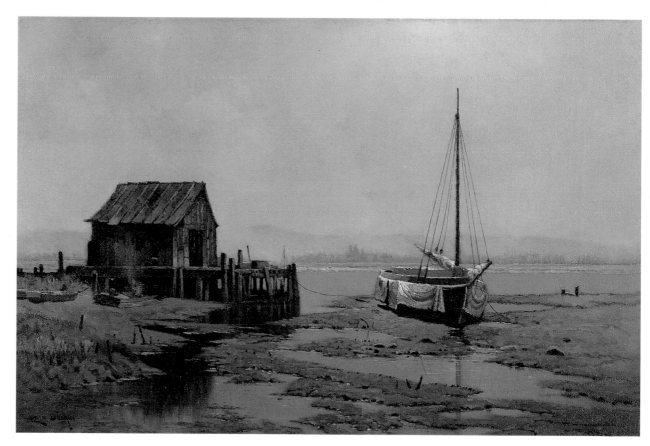

THE ARTIST'S SKETCHING
GROUND, ALAMEDA,
c. 1881

Oil on canvas, 16 x 24 in.
Private collection, courtesy
of Garzoli Gallery

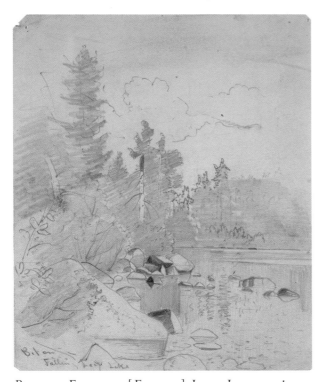

Bit on Falling [Fallen] Leaf Lake, n.d.

Graphite on paper, 8 3/4 x 7 1/4 in. Crocker Art Museum,
gift of Dr. Oscar Lemer, conserved with funds provided
by Théa and Chuck Givens

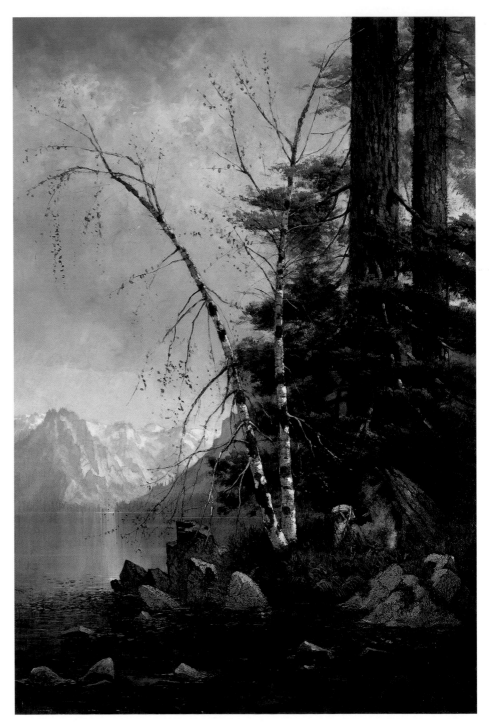

Fallen Leaf Lake, n.d.

Oil on canvas, 36 x 24 in.
Collection of the McKesson Corporation

In the late winter of 1874, Deakin completed another painting from his trip, *Morning in the Sierras.* Exhibited at Nile's gallery on Kearny Street, it depicted a valley and a sinuous stream among snow-topped mountains. In March, the ambitiously scaled *Cascade Falls at the Head of Cascade Lake* appeared at the gallery of Snow and Roos, and in April Nile's displayed a view of Mount Tallac from Cascade Lake and a "spirited piece of landscape drawing," *Forest Brook.* The *Bulletin* made a prediction: "A close student to his profession, and a thorough adept in the rules of his art, Deakin's future is bound to be an illustrious one."[39]

Deakin completed other paintings throughout the spring, including a new series of New York scenes along with his favored Lake Tahoe and Donner Lake subjects, the latter allowing him to flaunt his ability to paint water.[40] He also began planning new sketching excursions in order to gather material to fulfill the commissions he had received. In July, he journeyed to the Sierra and Yosemite, making steep climbs and putting himself in harm's way in order to capture the perfect vista. "He is very venture-some," a reporter declared, "and once at Cascade Falls, Cascade Lake, climbed up the face of almost inaccessible rocks, throwing his sketching material from ledge to ledge."[41] By August Deakin was back in San Francisco, producing paintings from along the Rubicon Trail connecting the Sacramento Valley and Lake Tahoe. The change in subject was welcome. A writer from the *San Francisco Illustrated Press* sighed, "To those tired of the eternal reproduction of Tahoe this will prove a relief."[42]

That fall, Deakin exhibited landscapes such as *Bear Valley* and *View from the Truckee* at Morris, Schwab & Co. The latter, some

critics felt, exhibited a technique that surpassed that of many of his contemporaries.[43] Enjoying wide critical praise, Deakin contributed several landscapes and architectural subjects to an auction at H. M. Newhall & Co. in November 1874. These included *A Quiet Nook* ($65), *Tallac Mountain* ($160), *Mission Dolores Church* ($52.50), *Mansion House* ($52.50), and *Forest Brook* ($75). *Cascade Lake* fetched the highest price, at $315. *Fallen Leaf Lake* sold for less, $160, but generated more excitement because the eminent landscapist Thomas Hill purchased it.[44] The following February, Deakin auctioned another seventy-one of his paintings at Newhall & Co. *Snow Water Lake, Wasatch Mountains, Utah* sold for the most—$450—and total sales amounted to $4,500.

Following the sale, Deakin set off on a sketching trip to the "most picturesque parts of the Pacific Coast," including Southern California, which he visited in the company of the genre painter William Hahn.[45] By May, he was back in San Francisco finishing a large Southern California landscape and involving himself in the city's art activities. In summer, members of the San Francisco Art Association appointed Deakin to the art committee for the Mechanics' Institute exhibition, which boasted some of the city's most prominent artists, including his close friend Samuel Marsden Brookes. Deakin contributed two works to the exhibition, his four-by-eight-foot *Wasatch Mountains, Utah,* and *Fallen Leaf Lake,* which he borrowed back from Thomas Hill. In August 1875, he began planning historical paintings for the American Centennial of the coming year.

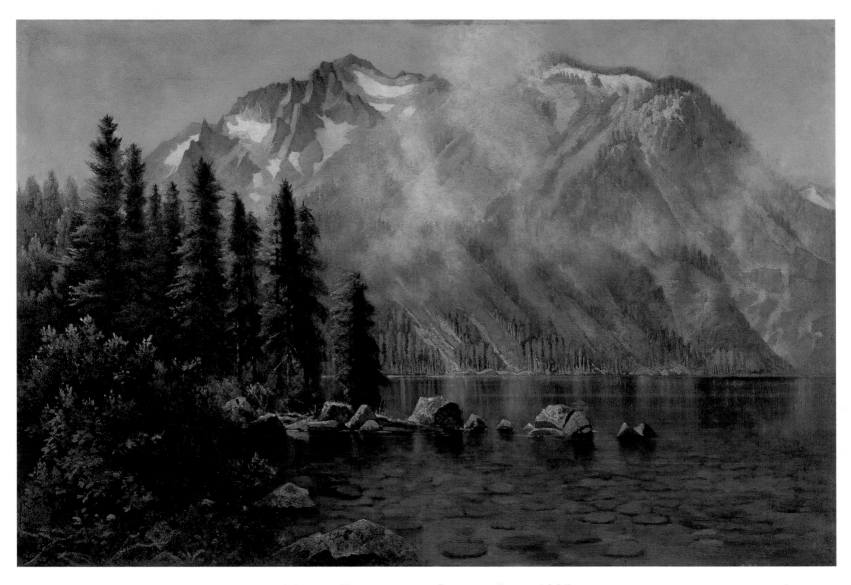

MOUNT TALLAC FROM CASCADE LAKE, 1895

Oil on canvas, 20 x 30 in. Collection of Bette and Stewart Schuster

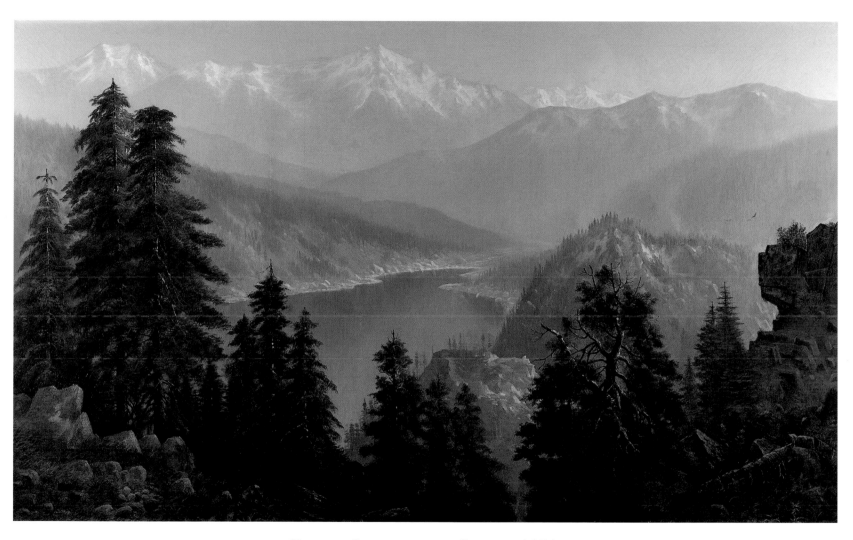

DONNER LAKE FROM THE SUMMIT, 1876

Oil on canvas, 44 x 72 in. Private collection

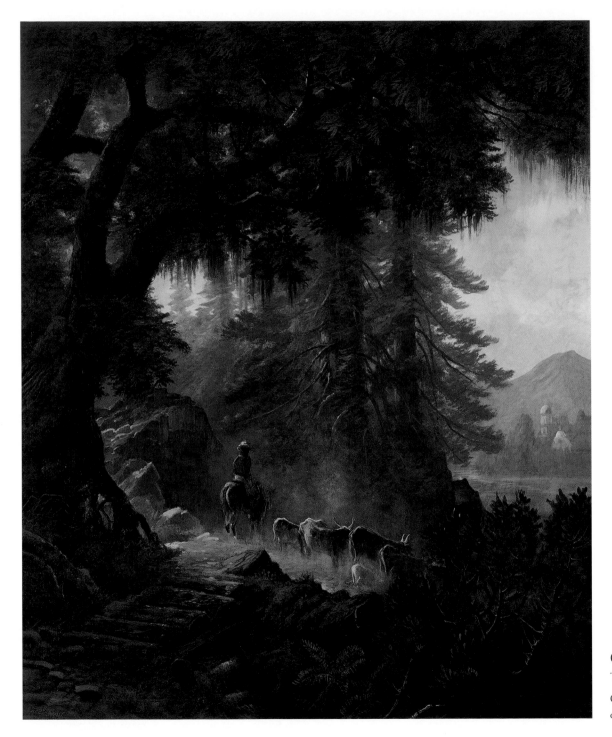

CATTLE DRIVE NEAR
THE MISSION, 1876

Oil on canvas, 30 x 25 in. Collection
of Mr. and Mrs. Fred Vierra

PICTURESQUE PAINTERS
DEAKIN and BROOKES

Deakin and his fellow Englishman Samuel Marsden Brookes shared a common philosophy concerning life and art. To reduce expenses, from 1875 the artists kept adjoining studios on Clay Street, in the same building that Deakin had occupied four years earlier. Deakin had not yet begun to pursue still-life painting, Brookes's specialty, which decreased the potential for rivalry. Together they made sketching trips around the San Francisco Bay, Lake Tahoe, Donner Lake, Yosemite, and Mount Shasta to obtain material for landscape paintings. Brookes also sought out still-life subjects. Best known for his paintings of fish, he made the journey to Shasta especially to paint Dolly Varden trout and spawning salmon.

Deakin painted Brookes in their ramshackle studios multiple times.[46] The disheveled rooms were well known among their fellow artists and elicited much comment from reporters, who marveled at the conditions in which the artists worked.[47] "As for Brookes and Deakin, they have reduced discomfort, and the knack of living in a muss to a science, and the visitor is as likely to sit down in a box of paints as he is to thrust his feet into a smoking cap," noted an incredulous writer.

These two artists have established themselves right under the eaves of a tall, dingy house on Clay street, and their bits of rooms, gorgeous alike in the splendor of paintings and wealth of rubbish are to be reached by climbing a mile or

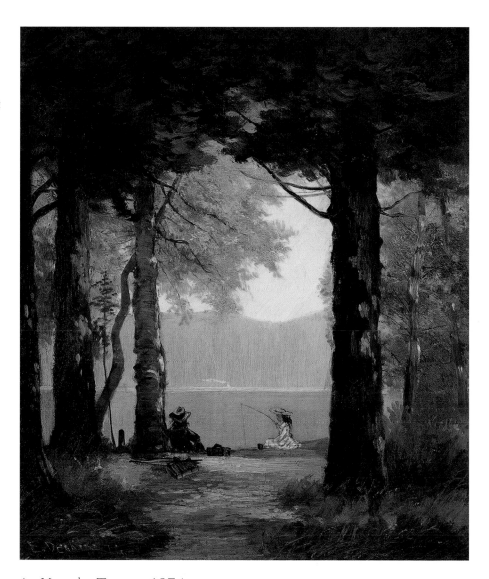

AT YANK'S, TAHOE, 1874

Oil on canvas, 12 x 10 in. Collection of Richard Pettler and Wanda Westberg

39

two of twisting, creaking, narrow stair case. The game is worth the candle, however, for a half hour spent under the eaves of this house in these two little studios, is the pleasantest dissipation one can have: for what with the painting that goes on in a desultory manner, and the piquant bits of badinage and spicy gossip that are tossed about, the woe begone forlornness of the room is entirely forgotten.[48]

Deakin completed his first version of *Artist's Studio* in 1876 and sold it that same year.[49] In it, Brookes paints fish at his easel amid studio furniture, paintings, and other accoutrements. San Francisco audiences appreciated the work's unusual subject and minute detail. Today these images of Brookes in his studio are ranked among Deakin's most important contributions to nineteenth-century California art, but Deakin intended them to be ironic. "Strange to say," a reporter noted, "the artist himself does not place this in a front position in his album."[50]

The paintings, in fact, spoofed the life of an artist. They were "tragedies" meant to amuse and, at the same time, "create sympathy for artists in general and their families." The first painting humorously depicted Brookes nearly "fainting, overcome by the completion of a large—very large—fish picture, a whale in fact,"

> and being caught in the arms of (Brookes *fils*) a huge mess of fish and a demijohn of Cutter Whisky, which has been used a month or so as models for the picture, are to be close by, leaving it an open question whether the smell of the fish, the tasting at the demijohn, or the ecstatic joy, mingled with mental and physical prostration, incident

to the successful completion of such a great work (6 x 10 feet), had been the cause of his undoing.[51]

The studio's disarray, and references to the empty demijohn of whisky—"its normal condition"—as well as Deakin's need to share expenses, all suggest a darker side to artistic life.[52] Deakin's tight financial straits were shared by many San Francisco artists at the time. The city's art market was sluggish in the late 1870s and early 1880s; local patrons bought European paintings while California artists struggled for recognition and sales.

PARADISIACAL RETREATS

INTIMATE LANDSCAPES

In late 1875 and into 1876, Deakin began to narrow the scope of his Bay Area subjects. These new landscapes departed from tradition and Deakin's previous efforts in their intimate, close-range depictions of small waterfalls, creeks and ponds, and clumps of trees. Although such focused scenes were relatively uncommon in California, works by the French Barbizon painters, known for simple, pastoral scenes painted directly from nature, were becoming internationally known and proving influential. At Nile's gallery, Deakin displayed two "cabinet pictures" of Fern Creek, in what is now Muir Woods, and Strawberry Creek in Berkeley. Deakin especially liked to paint Strawberry Creek's meander through mossy trees; he produced several views of the subject over the course of his career.

Even in the 1870s, a period early in California's development and a time of abundant, open nature, Deakin's close-up

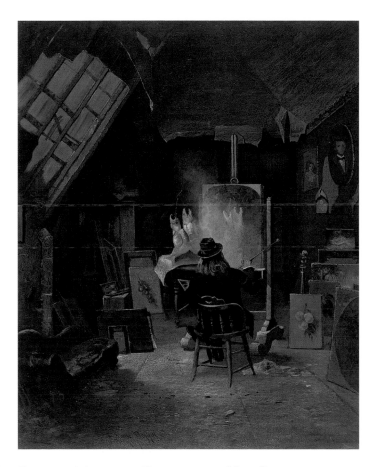

SAMUEL MARSDEN BROOKES IN HIS STUDIO, 1876

Oil on canvas, 20 x 16 in. Fine Arts Museums of San Francisco, gift of Mrs. Virginia Dakin

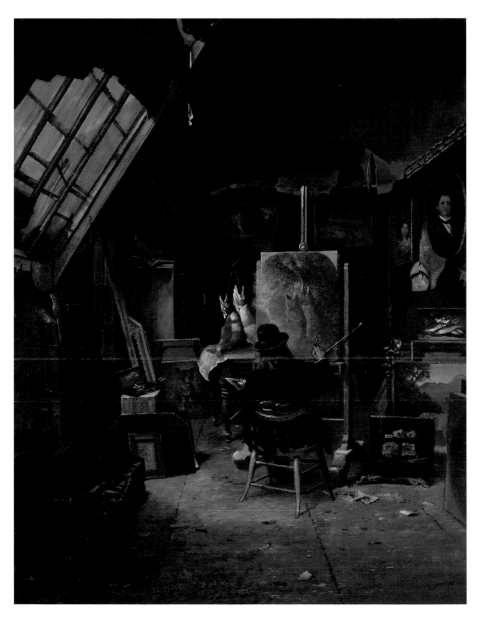

SAMUEL MARSDEN BROOKES PAINTING IN HIS STUDIO, 1876

Oil on canvas, 36 x 28 in. Collection of Cantor Arts Center at Stanford University

renderings of the picturesque offered a soothing escape from urban life. "The peculiarity of this artist's pictures is that they grow upon you, and you like them better day by day," one writer observed. "They grow upon you like the honest faces of tried friends."[53] The paintings spoke to a changing focus in landscape painting, from natural grandeur to something more intimate and meditative. Another reviewer wrote of Deakin's new landscape style:

> The cool, wild-wood green of these pictures is capitally managed, bringing many a heartfelt sigh from the bosom of pedestrians on the hot, asphaltum sidewalks; men and women, city weary, with vivid memories of just such paradisiacal retreats, like a past heaven. The tone of these companion pictures is exceedingly agreeable; sheltered aisles with columned perspective of graceful trees, reflecting in the cool, placid brook, an atmosphere of grateful protection from the noon-day scene.[54]

The popular perception of nature was changing as well—from something to be exploited in mankind's service to something to be cherished for itself. In the coming decades, many of the "paradisiacal retreats" that Deakin portrayed would be preserved, thanks to the naturalist John Muir and others who promoted a new reverence for California's wilderness. As founding president of the Sierra Club (1892), Muir inspired and guided preservationists to push for government protection of nature. Key successes included preservation of the region around the Yosemite Valley (1890), Big Basin near Santa Cruz (1902), and Muir Woods in Marin County (1908).

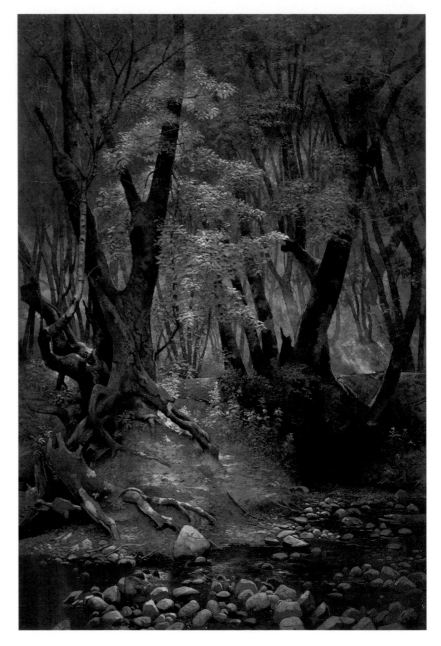

STRAWBERRY CREEK [Berkeley], 1893

Oil on canvas, 54 x 36 in. Crocker Art Museum, long-term loan from the California Department of Finance, conserved with funds provided by Louise and Victor Graf

Deakin sold many of his introspective scenes, including *Forest Dell, Fern Creek, Cataract Falls,* and *Woodland Brook,* in a group auction at H. M. Newhall & Co. in November 1875. He also contributed more expansive landscapes, such as *Cascade Lake, Mount St. Gabriel,* and *View from Cornelian Bay, Lake Tahoe,* and sold an early mission painting of San Buenaventura in Southern California.

In January 1876, Deakin contributed another "bit of wood scenery," this time of a shallow pool among the trees on the North Fork of the American River, to the winter exhibition of the San Francisco Art Association. The piece, and others he had painted in the same modest vein, drew mixed reactions from the critics. A reviewer for the *Alta* was thrilled, calling Deakin's quiet American River subject a "very clever picture."[55] Another urged Deakin to abandon his more traditional subjects, opining that "Yosemite and Donner Lake have now been done to death. These two subjects have used up an immense breadth of canvas, while a great many charming nooks in the State have been waiting for the original touch of the artist."[56] The *News Letter* disparaged the painting as "the worst picture in the room," faulting it not for lack of technical quality but for its departure from convention. "That Deakin has talent in the matter of handling the brush there is no doubt," the reporter conceded, "and if he would apply himself to the task of learning from some master, discarding entirely his own peculiar notions of painting, Deakin would in short time paint a picture worthy of the name."[57]

FROM DONNER LAKE
TO TRUCKEE RIVER, 1877

Graphite on paper, 4 3/4 x 8 in. Crocker
Art Museum, gift of Dr. Oscar Lemer,
conserved with funds provided by
Susana and Aj Watson

MONSTROUS DAUBS

CRITICAL RECEPTION

Critics often disagreed about the merits of Deakin's work. Some labeled it "pre-Raphaelitism" or "mechanical," implying that his technique was labored and too reliant upon nature's outward appearance. Others appreciated its "truthfulness." Early in his career, especially as Deakin attempted to establish his own style and path, and just as Barbizon techniques and subjects were coming into fashion, California critics argued among themselves about what landscape painting should be, and whether or not Deakin's work met these parameters.

The first criticisms, not for rendering nature too naturalistically but for departing from it too much, came in the year of his arrival in San Francisco. Hector A. Stuart, alias Caliban, wrote for the *San Francisco Call:* "Mr. Deakin, a new artist, or at least one little known, shows a landscape of some nameless locality, which is remarkable for its bluish tone. It would require a pair of Muller's double lenses to see a fragment of merit in this unnatural production."[58] The *Overland Monthly* agreed that Deakin was romanticizing his subjects at the expense of truth: "Deakin had several [paintings] that . . . at least, do not violate a clause of the second commandment, being indeed no likeness of anything in the heavens above or the earth beneath."[59]

Often there was little critical consensus about the same painting. Of particular controversy was the six-by-ten-foot *Mount Shasta from Castle Lake,* which Deakin exhibited in early 1877 at M. D. Nile's gallery and then in the San Francisco Art Association exhibition. Deakin had spent several months on the enormous canvas. Rendered as seen from the base of the mountain near Strawberry Station, the impressive composition included Castle Lake, trees, and other "characteristic features of California scenery."[60] The *Alta* called the painting the "best picture ever painted by Deakin," finding its atmosphere to be "light, cool and refreshing—very grateful and out-of-doorish."[61] The *Chronicle* described it as "the most ambitious and the most creditable work of an industrious, painstaking artist."[62]

But many were troubled by the painting's bombastic presentation, which included a halo of draped red fabric rather than a frame. The *San Francisco Evening Post* chastised the artist:

> There was a general and pervading sense of dissatisfaction at the prominence given to a monstrous daub by a man of the name of Deakin, who evidently is a self-taught artist and imitator of Bierstadt. Without one single quality to recommend it, this trashy production was not only given a place of honor in the center of one of the ends, but it was surrounded with a crimson border, as if to distinguish it honorably from the rest.[63]

The *News Letter*'s "Art Jottings" columnist joined in the condemnation. "Of Deakin's 'Mount Shasta,' No. 64, but little need be said. It is neither better or worse, but quite similar to the very many other large pictures of this character which Mr. Deakin has given us during the past five years, and which have been referred to in the Jottings as having been utterly void of *artistic merit in every respect.*"[64] The painting, along with a similarly scaled work by James Hamilton, was even criticized for occupying too much exhibition space. "Had these two colossi been hoisted to the very ceiling," the *Evening Post* scolded, "they would positively have gained by it, as the public would actually have seen them to better advantage."[65]

ROMANTIC CHATEAUX
and RUSTIC BRIDGES

EUROPEAN SCENES

The opprobrium may have been too much for Deakin: he immediately planned an extended trip to Europe. There he sought to prove his abilities at the international level, thus silencing critics at home. In March 1877, he held a "farewell sale" at Newhall & Co. to raise funds for the trip. The prices realized were "fair," though not spectacular.[66] The *Chronicle* reported, "Mr. Deakin will leave for Europe in search of the grand and picturesque, on or about May 1st; hence the recent sale."[67]

Deakin's European itinerary included visits to the museums of Munich, Paris, and London for the purpose of "familiarizing himself with the works of the masters."[68] From San Francisco, he traveled via Panama, and also stopped briefly in Jamaica, later turning several tropical sketches he made on that leg of the voyage into paintings. Upon his arrival in Europe, he spent time in Switzerland, where he sought to depict the "lofty mountains, picturesque lakes, quaint hamlets and frowning castles."[69] At Lake Lucerne, Mount Blanc, and Lake Geneva, he captured mountains, lakes, and architecture in various combinations and to striking effect. Particularly awed by Lake Geneva's Castle of Chillon, he produced many views of the castle, the lake, and the towering Dent du Midi. More modest architectural subjects—village chapels, residences, and bridges—caught his eye as well.

By July, Deakin was in London. There he sketched cathedrals and churches, including Westminster Abbey and Stoke Poges, both of which he would feature in subsequent paintings. In early 1878, he went to Paris and visited the Louvre, Notre Dame,

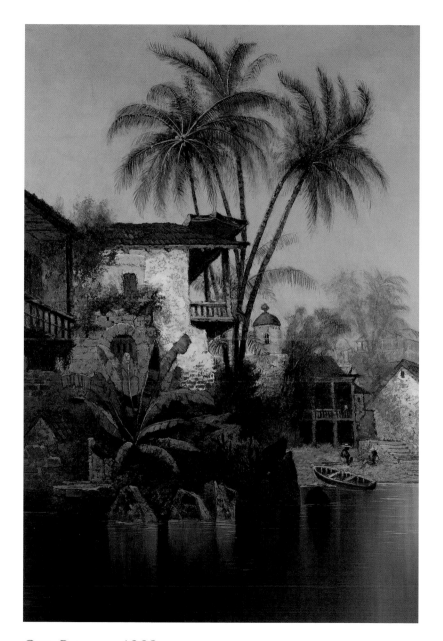

OLD PANAMA, 1883
Oil on canvas, 36 x 24 in. Collection of Joseph and Maria Fazio, courtesy of Garzoli Gallery

Hôtel de Cluny, and other historic structures. By March he was hard at work on a painting of Mount Blanc, which he hoped would be accepted into the Paris Salon, proving his ability once and for all. Lest his progress be overlooked, he kept the newspapers at home abreast of his plans. The *Chronicle* reported that "Edwin Deakin is in Paris painting Mount Blanc for the Salon. He has been spending most of his time since his arrival in Europe in sketching trips through Switzerland. He expects to leave Paris upon another sketching tour in June, and after that go to London, returning to San Francisco probably in the Spring of 1879."[70]

Mount Blanc was accepted into the 1879 Salon, and hung on the line; Deakin also secured acceptance for *Église de Chelles, Le Soir.* A stormy twilight view of a Gothic church, with a shepherd and flock in the foreground, the painting was both architecturally accurate and spiritually evocative. The subject matter and painterly treatment reflected Deakin's esteem for France's realist and Barbizon painters—particularly Millet, whose *L'église de Gréville* (*The Church at Gréville,* 1871–1874) clearly inspired Deakin when he saw it at the Musée du Luxembourg.[71]

Upon returning to San Francisco in May 1879, Deakin made sure that the press knew of his accomplishments. The *Chronicle* noted that "two of his pictures were placed in the Paris Salon, and he shows

the receipts with commendable pride."[72] Late that year, the Salon paintings made their way back to San Francisco for display in Deakin's studio, where they achieved the public acclaim Deakin sought. A *Chronicle* writer observed that both pieces "show that faithful study and attention to detail which have placed Deakin in the front rank of American artists."[73]

Deakin's first major painting following his return was a depiction of the Castle of Chillon on Lake Geneva. Some visitors to Deakin's studio claimed that the work in progress was certain to be his best yet.

The Castle of Chillon was rich in history. The rock on which it stood was inhabited in antiquity; the structure's earliest parts dated to the eleventh century, and it was modified and

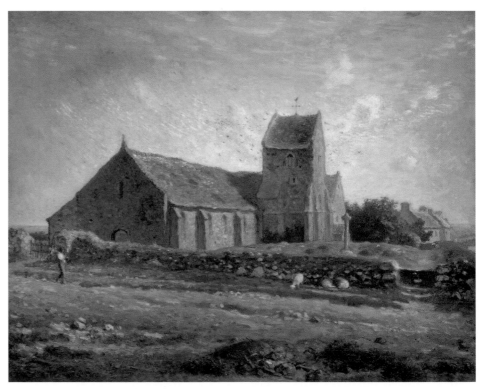

Jean-François Millet (1814–1875).
L'ÉGLISE DE GRÉVILLE, 1871–1874

Oil on canvas, 23 5/8 x 28 7/8 in. Musée d'Orsay, Paris.
Photograph courtesy Réunion des
Musées Nationaux/Art Resource, NY

ÉGLISE DE CHELLES, LE SOIR, 1879

Oil on canvas, 20¹/₄ x 30¹/₄ in. Crocker Art Museum, long-term loan from the California Department of Finance, conserved with funds provided by Gerald D. Gordon

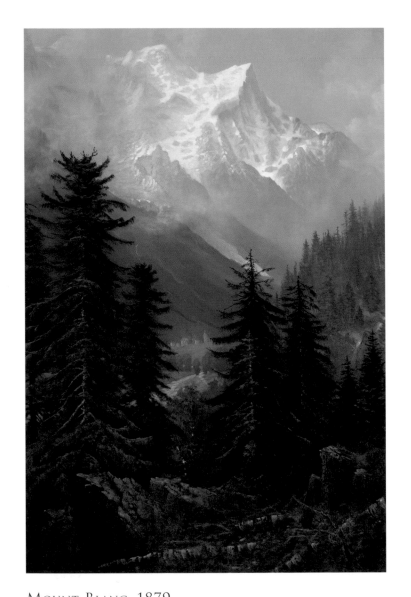

Mount Blanc, 1879

Oil on canvas, 36 x 24 in. Crocker Art Museum, long-term loan from
the California Department of Finance, conserved with funds provided
by Gerald D. Gordon

48

Entrance to Chapel, Hôtel de Cluny, n.d.

Oil on canvas, 54 1/8 x 36 1/4 in. Crocker Art Museum, long-term loan
from the California Department of Finance, conserved with funds
provided by Gerald D. Gordon

expanded by the Counts of Savoy in the thirteenth century. In Deakin's time, the castle was a popular tourist attraction, its fame enhanced by writers and poets—notably Lord Byron, who wrote *The Prisoner of Chillon* in 1816. Deakin certainly knew the poem, and it appears to have suggested some of the details that the artist chose to include.

Lake Leman lies by Chillon's walls:
A thousand feet in depth below
Its massy waters meet and flow;
Thus much the fathom-line was sent
From Chillon's snow-white battlement,
Which round about the wave inthralls

. . .

I saw the white-wall'd distant town,
And whiter sails go skimming down;
And then there was a little isle,
Which in my very face did smile,
The only one in view;
A small green isle, it seem'd no more,
Scarce broader than my dungeon floor,
But in it there were three tall trees,
And o'er it blew the mountain breeze,
And by it there were waters flowing,
And on it there were young flowers growing,
Of gentle breath and hue.
The fish swam by the castle wall,
And they seem'd joyous each and all;
The eagle rode the rising blast,
Methought he never flew so fast . . .

Completed in August 1879, the painting was the "first matured fruit" of Deakin's European tour.[74] Those who had high expectations for the work were not disappointed, and the *Chronicle* proclaimed the painting "the best thing he ever did."[75] Deakin too was pleased with the result. Over the next twenty years he produced many variations on the subject, including an 1894 version as large and ambitious as the original.

GRANDEUR and SOLEMNITY

ARCHITECTURE

Architecture began to emerge as Deakin's primary genre during his European trip. This was good fortune or good planning, because in California the art recession had worsened, and Hill, Keith, and others had saturated the market with landscapes. Deakin decided to pursue his new specialty in architecture and to produce smaller and more salable landscape subjects "suitable to the condition of the money market."[76] Shortly after completing his *Castle of Chillon,* Deakin began work on *A Church Door,* along with two snow scenes depicting the "quaint architectural beauties of Paris." He also began planning a view of Notre Dame, which many thought showed promise of being his "masterpiece"—if the painting could live up to the sketches.[77] By spring 1880, Deakin was at work on two views of Notre Dame—one a daylight scene full of architectural detail and the other an evening picture.

There were still those who continued to fault Deakin's work, finding his architectural subjects "pretentious."[78] For the most part, however, his new specialty was well received. "Of late Mr. Deakin has turned his attention to the painting of buildings

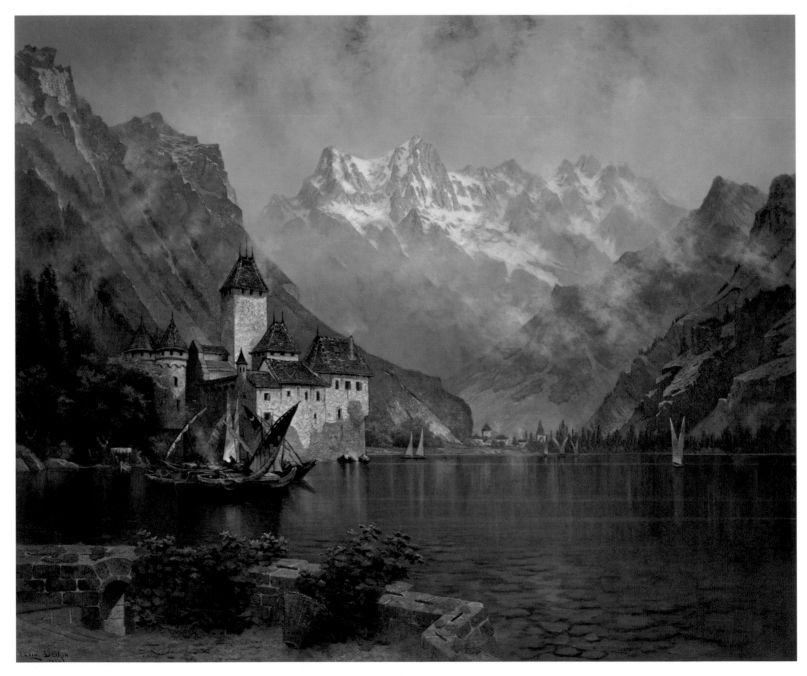

DENT DU MIDI [Castle of Chillon, Lake Geneva], 1894

Oil on canvas, 55¹/₈ x 66 in. Crocker Art Museum, long-term loan from the California Department of Finance, conserved with funds provided by Gerald D. Gordon

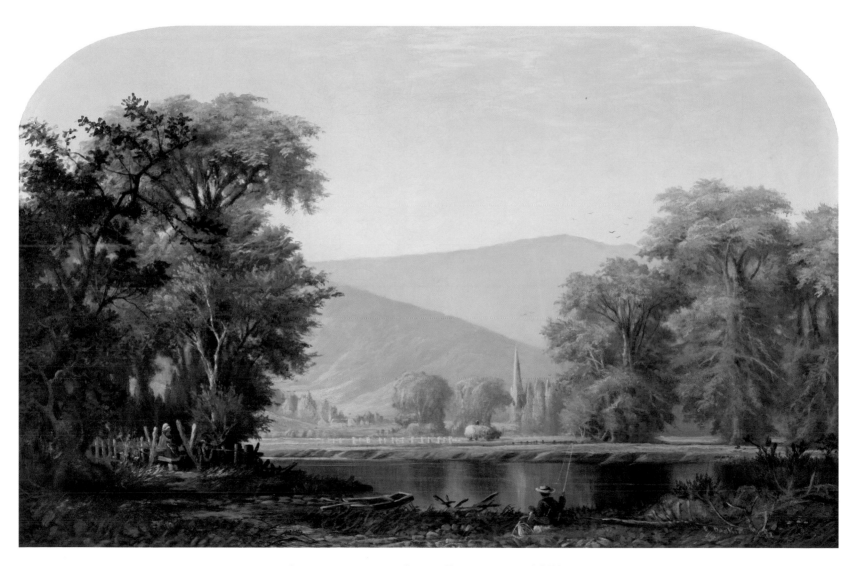

LANDSCAPE WITH LAKE, FISHERMAN, 1879

Oil on canvas, 18 x 28¹/₂ in. Collection of the Hearst Art Gallery, Saint Mary's College of California

and views not strictly landscapes," reported the *News Letter*. "This is his forte, and it must be said that he is very successful in the rendition of pictures of this character. His paintings in this collection are nearly all views of noted buildings abroad, and partake more of the character of object painting than any series of pictures this artist has yet offered the public."[79]

Deakin's treatment of architectural subjects was both "delicate and vigorous," using heavy outlines, a flattened application of paint, and a distinctive mottling of light on brick and stone that made his work immediately recognizable.[80] "If Mr. Deakin could paint anything at all, it was a hard stone wall," declared the *News Letter*'s reviewer.[81] The *Chronicle*'s critic agreed, with a facetious aside:

> Deakin has a much admired facility for painting a certain
> kind of gray stone, the like of which was hardly ever seen
> in nature. He has done so much of it that he probably
> paints it in his sleep. His foregrounds are all of gray stone;
> his skies are finished with the same; his "Rue Militaire" is
> a sketch of Angel Island, with the brick walls and houses
> turned to gray stone; his grapes hang on gray stone walls,
> and if he were to paint a portrait of a lady he would
> undoubtedly finish her with gray stone trimmings.[82]

In the winter of 1880, Deakin turned to painting scenes of Paris derived from his earlier sketches. Some of these were "snow subjects," which were admired by visitors to his studio for their "novelty and beauty."[83] One medium-sized canvas, *A Souvenir of Cluny*, featured a nun feeding sparrows at the Hotel Cluny on a winter day. The *Evening Post* found the architecture of the grand old building to be "shown with striking effect," and the "poetic sentiment" and technique also commendable.[84] The *News Letter* reviewer, always the most critical of Deakin's efforts, held a different opinion: "Had the snow, the birds and the figure been omitted, it would have been a much better picture than it is."[85]

The Cluny painting was popular, figure and all, and later that spring Deakin was commissioned to produce a smaller version. In August 1880, he finished a companion piece to the larger painting, an interior view of the Henry VII chapel in Westminster Abbey. One highly regarded winter scene from the early 1890s depicted a corner of Cluny on Christmas morning. Featuring an arrangement similar to his *Souvenir of Cluny*, it depicted an architectural corner with snow and birds. In this instance, Deakin heeded critical admonishment and omitted the nun in favor of a sunlit stained-glass window.

FAVORABLE MARKETS
MOVING EAST

Deakin had been in San Francisco for less than a year when he first began selling paintings in the Midwest and East, where the market held more promise. In early September 1880, he made an extended trip to Chicago and Milwaukee. In Chicago, he exhibited at O'Brien's Gallery and in a temporary studio space; in Milwaukee, he exhibited forty-four works featuring international subjects at Poposkey's Art Gallery. In all, he sold more than thirty paintings, including *Souvenir of Cluny* and its companion interior of Westminster Abbey. "It is true Mr. Deakin loyally claims San Francisco as his art home and asserts that California is a superior place in which to work, . . ." reported the *San Francisco Examiner*. "But he has arranged to forward pictures to

CHRISTMAS MORNING,
HÔTEL DE CLUNY, n.d.

Oil on canvas, 42¹/₂ x 28¹/₂ in. Crocker Art Museum,
long-term loan from the California Department of Finance,
conserved with funds provided by Gerald D. Gordon

the markets he has found so favorable, and next Spring he will go to New York, where he will establish himself, and hereafter will at least divide his labors between that city and San Francisco."[86]

Deakin returned to San Francisco in early November, but left for New York in January. Between trips, he completed a large painting of Notre Dame to be sent directly to the East. "One of the most perfect pictures ever made on the coast," it showed the cathedral from the bridge, with canal boats in the water below. Unhappy with local critics' response to his work, Deakin chose not to exhibit the piece in California. The *Examiner,* paraphrasing the artist, explained that because San Francisco was "comparatively small" and its art patrons "uninformed," the quality of the painting mattered little in terms of its sale—whereas the exhibition of a painting as complex as *Notre Dame* in an "art-loving community certainly could not but . . . vastly increase its monetary value."[87]

In March 1881, Deakin's Art Association colleagues appointed him to the "rejecting committee" for the association's exhibitions, giving him an opportunity to assert his opinions. The jury, whose members included Jules Tavernier, was assembled to maintain high standards and "banish . . . all 'potboilers' and painted trash" from association shows. Although jurors established what they believed to be a fair, majority-rule system of anonymous written comments, the rejection of many artists' works, including some by the association's most prominent members, caused much "heartburning, jealousy and ill feeling."[88] Ultimately the committee members' qualifications were called into question. The fact that the jurors were allowed to submit their own works added to the controversy.[89]

Deakin was becoming weary of the "jealousy, and envy and spite" of San Francisco art politics and tired of those artists who "stood in the way of the advancement of others."[90] In the midst of the Art Association uproar, he made plans to relocate his family and studio to New York, his confidence bolstered by his success in selling work at venues there and in Milwaukee and Chicago. Several prominent artists had left or planned to leave San Francisco, a cause for concern among the art community and press. The *Examiner* noted that Deakin "frankly admits that he leaves this his favorite city because it does not pay and he can do better in New York, where several of his pictures, exhibited a year ago, sold readily and brought good prices."[91] The *San Francisco Post* was less diplomatic: "The field here is too narrow for him. It does not pay to till his brains to reap a barren harvest."[92]

In late September 1881, Deakin exhibited many of his paintings in the Art Association's galleries, where they were to be sold to fund the New York trip. Those that did not sell were auctioned in the association galleries in October. The weather was stormy on the day of the sale, and there were few bidders. The highest price paid was $525, for *Mount Shasta.* A number of paintings fetched $100 or less. Deakin withdrew his two Salon paintings rather than sacrifice them. The total net of just over $2,500, though disappointing, was enough to finance the trip.

Deakin took with him a group of paintings to show dealers in the East. These included a variety of international subjects and styles such as *On the Marne,* a painting described as "characteristically French," and a copy of a stormy English landscape by Constable, painted directly from the original in the Louvre. In a change of plans, Deakin did not settle in New York, but instead chose Cincinnati as a favorable community with "few

notable competitors." By December, he was engaged in fitting up his Cincinnati studio, and he soon began exhibiting locally and visiting other midwestern cities, particularly Milwaukee and Chicago, to sell paintings.[93] He also continued to exhibit his work in San Francisco.

In July 1882, Deakin moved with his family again—this time to Denver. There he took an elegant studio in the Academy of Fine Arts, located within the Tabor Grand Opera House, and produced an "enormous amount" of paintings, varied in subject and treatment, including a new group of "fruit studies" featuring grapes, peaches, apples, and plums. One painting, of which the artist was especially proud, combined still life, architecture, and landscape by depicting grapes in the windowsill of an old stone château with Lake Geneva and the Castle of Chillon visible beyond. The local papers were pleased to have an artist of Deakin's caliber in their midst, calling him "the best artist who has ever visited" and urging citizens to visit his studio and buy enough pictures "to induce him to come again."[94] At first, Deakin realized few sales and continued to send paintings to the East, but by the end of his stay he had sold several canvases to prominent families.

Deakin stayed in Denver for only a year before heading west. Finding many "artistic subjects" in Salt Lake City, he lingered there, to the delight of the local press, exhibiting fifty paintings in his studio and producing numerous drawings and oil sketches that later served as the basis for paintings, as well as finished works.[95] Selling little, he returned to San Francisco by November and exhibited paintings from the trip, including *An Old Mill at Salt Lake City (Built by Brigham Young)* and *Wasatch Mountains at Sunset, from near Salt Lake City,* at the spring exhibition of the San Francisco Art Association.[96] According to the *San Francisco Evening Post,* his art had "evidently much improved since he left."[97]

THE BLACKSMITH'S SHOP AND
OLD MILL AT SALT LAKE CITY, 1894
Oil on canvas, 24¹/8 x 16¹/8 in. Private collection

PICTURESQUE BITS and OUT-OF-THE-WAY PLACES
Still Life and Chinatown

With spring's arrival, back in the Clay Street studio he had once shared with Samuel Marsden Brookes, Deakin began to paint still lifes in earnest, especially grapes before stone walls. He showed three of these new subjects in the spring San Francisco Art Association exhibition and announced that he would continue painting fruit for the rest of the season. He subsequently created *An Offering to Bacchus,* one of the most ambitious fruit studies ever painted in the city. The painting brimmed with an abundance of grapes—"all the finest California varieties"—in a recess of an ancient stone temple. Deakin was pleased with the painting and planned to send it east for exhibition, perhaps ultimately to the Paris Salon.[98] He would paint at least one later version.

In October 1883, with fellow artists Jules Tavernier, Theodore Wores, Oscar Kunath, John Stanton, Henry Alexander, Alfred Rodriguez, and Lorenzo Latimer, Deakin visited Chinatown to see a parade. The experience prompted a new direction in his painting. According to the *San Franciscan,* the artist had been "scouring the city for picturesque bits and interesting out-of-the-way scenes."[99] He found them in Chinatown's colorful alleyways. Other artists, notably Wores and Alexander, were already producing Chinatown subjects, mingling the attraction of the local with the late nineteenth-century interest in exoticism and "otherness." Critics found Deakin's colorful Chinatown scenes a welcome change, "a decided improvement on his usually chilly architectural work."[100]

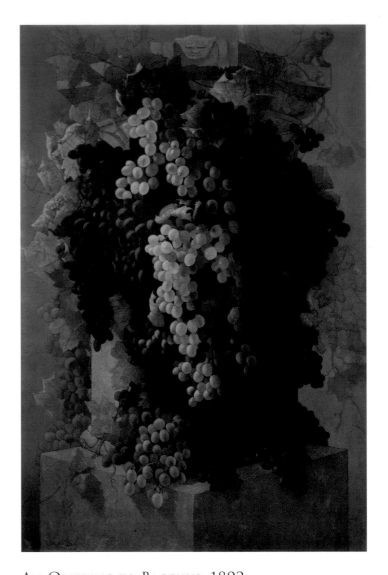

AN OFFERING TO BACCHUS, 1892
Oil on canvas, 36 x 24 in.
Oakland Museum of California, gift of Mrs. Leon Bocqueraz

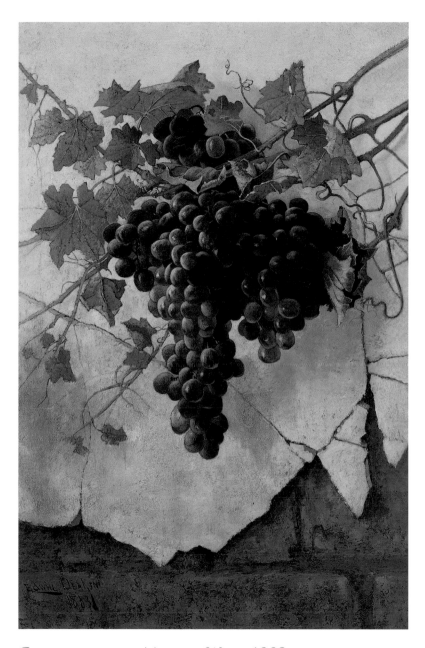

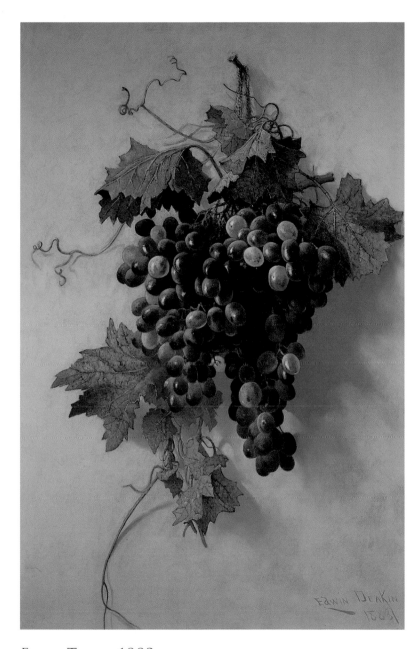

GRAPES AGAINST A MISSION WALL, 1883

Oil on canvas, 24 x 16 in. Private collection, courtesy of Garzoli Gallery

FLAME TOKAY, 1883

Oil on canvas, 24 x 16 in. Partial and promised gift by
William and Abigail Gerdts to the National Gallery of Art

Deakin exhibited three pieces in the San Francisco Art Association's 1885 spring exhibition. Two were new subjects: *The New Vintage,* the "largest grape piece ever attempted by a local artist," and *Street in Chinatown.*[101] A reviewer from the *Chronicle* found these "so much better that they do not seem to be painted by the same man. His grape picture, 'The New Vintage,' is full of clever work. . . . But his 'Street in Chinatown' is even better, being handled with unusual freedom, rich in color and values and happy composition."[102]

Deakin sold his Chinatown scene almost immediately and undertook others that summer. His success prompted Fingal Buchanan of the *San Franciscan* to ask:

> Why do not our artists paint more Chinese and Japanese subjects? Surely not for want of opportunity. Our city offers subjects in plenty, models in plenty. . . . Deakin found his European cathedrals begging purchasers year after year. He painted one good study of a street in Chinatown, and a wealthy tourist bought it at once. Why don't he repeat the effort? If a traveler or collector wants to own a picture of a European subject, will he not naturally buy it in Europe? If he wants to buy in San Francisco, does he not naturally want to choose something local, distinctive, and picturesque?[103]

In late 1885, Deakin made a brief visit to New York. Upon his return to San Francisco, he found a still life he had arranged in his studio shriveled and dried. The dessicated grapes and leaves offered new possibilities, and Deakin painted them, calling the result *The Last of the Vintage.* He also sketched Chinatown and finished a painting entitled *Mission Dolores as It Appeared*

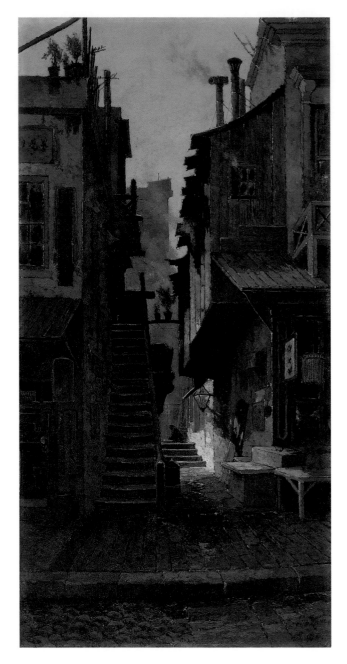

COURT IN CHINATOWN, SAN FRANCISCO, 1886
Oil on canvas, 30 1/8 x 15 in. Fine Arts Museums of San Francisco, bequest of Edith Clark Mau

ROSS ALLEY, CHINATOWN, c. 1886

Oil on canvas, 18 x 12 in. Private collection,
courtesy of Garzoli Gallery

STUDY IN CHINATOWN,
SAN FRANCISCO, CALIFORNIA, 1886

Oil on canvas, 30 x 20 in.
Private collection, courtesy of Garzoli Gallery

STREET IN CHINATOWN, SAN FRANCISCO, 1905
Oil on canvas, 41⅝ x 20½ in. Long-term loan to the Nevada Museum of Art, Reno

in 1870. And he held another art sale, offering more than one hundred pictures, sketches, and studies.

In 1886, Deakin completed another painting of Brookes in his studio. Ten years had passed since he had last undertaken the subject, and he may have done so now as a remembrance of the studio, which he had relinquished to Charles Rollo Peters and John Stanton upon moving to Sutter Street. He was also working on several new Chinatown subjects intended for the Art Association's spring exhibition. That fall, judges at the California State Fair in Sacramento awarded him a silver medal—"Best Fruit Piece"—for one of five paintings he exhibited there. The following year he won the fair's grand prize (a gold medal and $50) for the most meritorious display of oil paintings by a resident California artist.

Gratified and encouraged by the praise he had also been receiving from New York, Deakin made a lengthy visit there beginning in December 1886; he spent most of the winter working in his studio, painting California grapes from sketches. In June 1887, he returned to San Francisco and rented a space at 728 Montgomery Street, where many artists had studios. Late that year and in the spring of 1888, he held two sales of his work. The market remained capricious, and the first auction was more successful than the second. "Fruit is not having a good sale just now," the *Chronicle* reported, "excepting from peddlers' wagons."[104]

Deakin continued to send paintings to the state fair. In 1888, he offered thirty-three works, including a wide variety of American and European landscapes, still lifes, architectural and street views, and other "rustic" scenery; all were auctioned at the close of festivities. "Very seldom has a finer opportunity

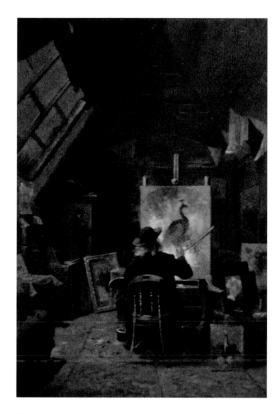

SAMUEL MARSDEN BROOKES
PAINTING IN HIS STUDIO, 1886

Oil on canvas, 23¹/2 x 15¹/2 in. Courthouse Museum,
Shasta State Historical Park

been offered in Sacramento to secure some of the best works of
a foremost landscape artist," the *Sacramento Daily Record Union*
reported.[105] Deakin told the paper that this was because he would
settle for nothing less than his best efforts; some of the canvases
had two or three paintings on them, because he would paint one
picture over another when he was not satisfied with the first. (The
backs of Deakin's paintings frequently have multiple titles and
dates, sometimes painted out, in testimony to this practice.)

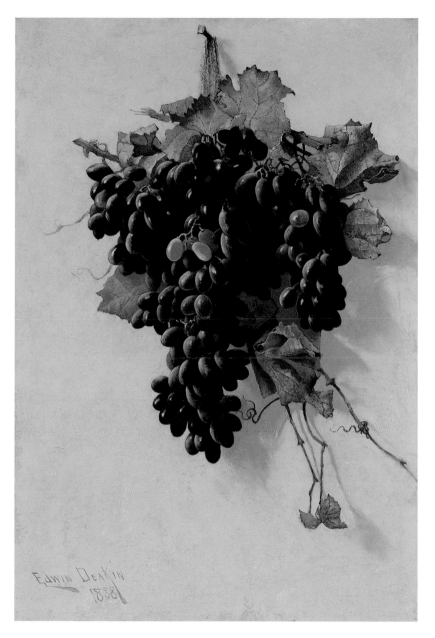

STILL LIFE WITH GRAPES, 1888

Oil on canvas, 24 x 16 in. Smithsonian American Art Museum, Museum Purchase

POETIC SENTIMENT
LITERARY PAINTINGS

Seeking new sources of inspiration, Deakin returned to Europe in June 1888, spending six weeks visiting London, Paris, and surrounding towns. Soon after his return, he once again began painting European subjects in earnest; this time, several included narrative. The artist undertook an interior view of Westminster Abbey with an old gentleman sitting on a pair of steps, his head resting in his hand and an "an air of utter woe upon him."[106] The painting combined Deakin's love of architecture with the story of Charles Dickens's *The Old Curiosity Shop.*[107] The painting, *She Will Come Tomorrow,* evoked the visit by Little Nell's grandfather to her tomb. Elements such as Nell's straw hat, the lunch basket brought by the grandfather in expectation of meeting her, and a marble slab, highlighted by a shaft of sunlight, marking her resting place, conveyed the poignancy of the moment. Outside in the church courtyard Deakin included trees and birds, echoing Dickens's lines: "The boughs of trees were ever rustling in the summer, and where the birds sang sweetly all day long. With every breath of air that stirred among those branches in the sunshine, some trembling, changing light, would fall upon her grave." Viewers enjoyed this new literary element in Deakin's work, and the artist considered the painting his best to date.

The church in Dickens's story was not Westminster Abbey, but Deakin felt that only that cathedral, in its "grandeur and solemnity," could do justice to the narrative. He even obtained special permits to sketch there. According to the *San Francisco Chronicle,* the result was a painting that aroused "all the sympathy and peculiarly sad feeling caused by the pathetic writ-

ings" and even recalled Dickens's lines: "Oh! It is hard to take to heart the lessons that such deaths will teach, but let no man reject it, for it is the one that all must learn and is a mighty universal truth."[108]

In the spring of 1889, Deakin sent *She Will Come Tomorrow* to New York for exhibition; he followed soon thereafter, with the aim of having the piece reproduced as an etching. He then took the painting to Denver, exhibiting it to further critical praise.

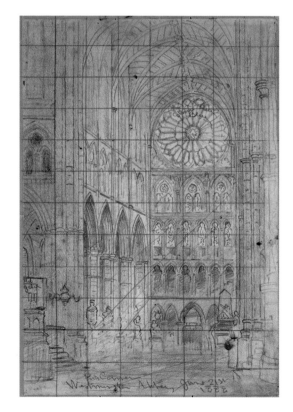

POETS' CORNER—WESTMINSTER ABBEY, JUNE 21, 1888

Graphite on paper, 12 x 8 1/4 in. Crocker Art Museum, gift of Dr. Oscar Lemer, conserved with funds provided by Susana and Aj Watson

Buoyed by this success, that summer in San Francisco he began painting other "literary" subjects. One such painting featured St. Giles Church in Stoke Poges, Buckinghamshire, the inspiration for Thomas Gray's "Elegy Written in a Country Churchyard," as Deakin noted on the back of the canvas.[109] Other works in the literary vein followed, such as a painting he made of an aged structure at Issy-les-Moulineaux near Paris. This time his lines on the canvas back borrowed from the novelist Charles Kingsley:

> So fleet the works of men, back to the[ir] earth again;
> Ancient and holy things fade like a dream.[110]

Deakin did not neglect his still lifes, and mission scenes increasingly occupied him. In the fall of 1889, he produced paintings from sketches he made in the East. He also completed and placed on exhibition *Houses of Parliament on the Thames Embankment,* a painting successful enough to spawn forgeries.

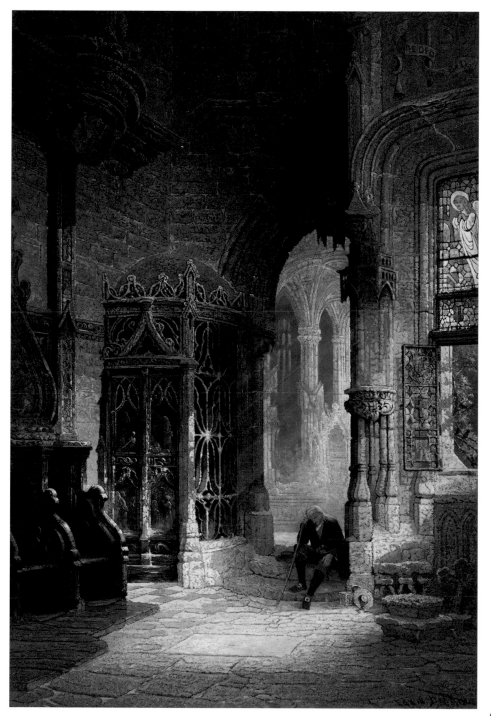

SHE WILL COME TOMORROW, 1888

Oil on canvas, 42¼ x 28¼ in. Crocker Art Museum, long-term loan from the California Department of Finance, conserved with funds provided by Gerald D. Gordon

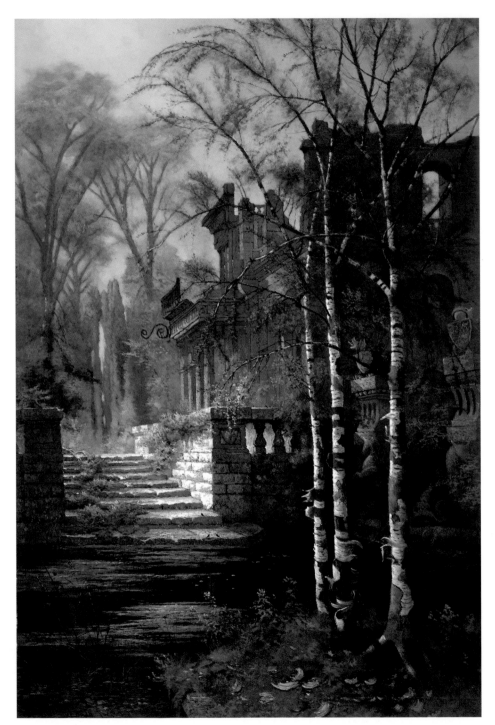

SO FLEET THE WORKS, 1895

Oil on canvas, 42 5/16 x 32 1/8 in. Crocker Art Museum,
long-term loan from the California Department of Finance,
conserved with funds provided by Gerald D. Gordon

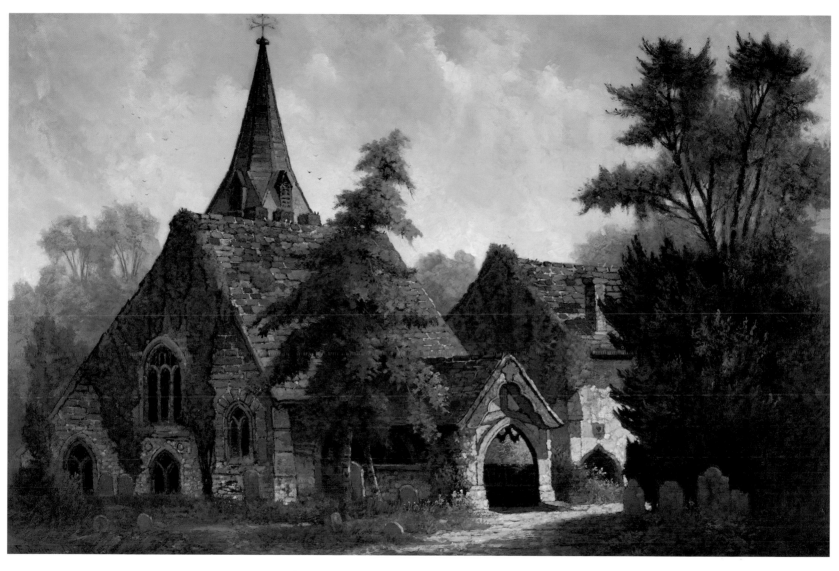

STOKE POGES CHURCH, ENGLAND, n.d.

Oil on canvas, 20¹/₄ x 30¹/₈ in. Crocker Art Museum, long-term loan from the California Department of Finance, conserved with funds provided by Gerald D. Gordon

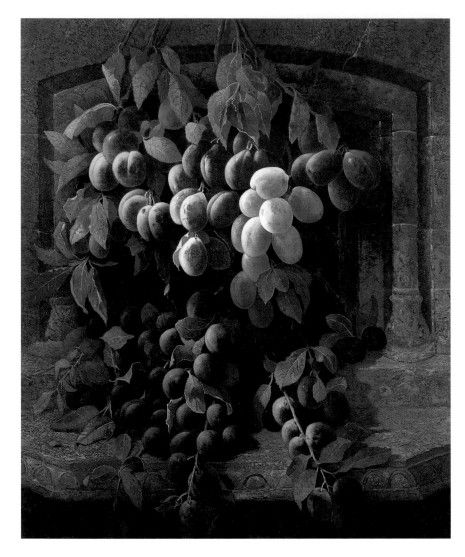

Oil on canvas, 30 x 25 in. Private collection, courtesy of Garzoli Gallery

PICTURE PIRATES

FORGERIES

In a matter of days, an unauthorized copy of *Thames Embankment* was hanging for sale in a San Francisco gallery.[111] Deakin was just one of many local artists whose works were forged and marketed as originals. Although his highly individualistic style seemed to make "a Deakin a Deakin all the world over," talented plagiarists could convincingly mimic his technique.[112] Deakin complained:

> I have suffered more, perhaps, than any other artist in San Francisco. My pictures have been copied and the city almost placarded with them. Why, I have seen fifty copies of my "Mission Dolores," and pretty fair copies, too. Some time ago a friend of mine told me he had seen the picture in the office of a well-known attorney, one who rather prides himself on his judgment of works of art. I knew this gentleman did not possess the original and thus found out that the picture had in some way fallen into the hands of the pirates. . . .
>
> But I don't care so much about this. It is the effect on my regular patrons. I have had people come to me and say "Deakin, I did not think you would ever paint daubs for an auction room." They had seen imitations of my pictures in shop windows and came to the conclusion without taking a second look, that the work was mine. . . .
>
> There is no help for it that I can see. The only thing left for artists in San Francisco to do is to close

their studios and leave the city. There is no use trying to down the "picture pirate." He will survive as long as the dealers are permitted to practice the deception they do now, and this will be until the enactment of a practical copyright law that will protect us.[113]

PAST HEAVEN

BERKELEY

Having declared that the only thing possible for an artist to do was move, Deakin left San Francisco, although he continued to maintain a studio presence there. In 1890, he purchased part of the Peralta Estate in Berkeley, a property bounded by present-day Deakin Street, Telegraph Avenue, and Webster and Woolsey Streets. In this setting, he built a mission-style home and studio, where he lived and worked for the rest of his life.[114] From his new home, Deakin sketched and painted scenes in and around Berkeley. Strawberry Creek became his favorite subject, depicted directly from the source in small oil studies and larger, finished works. Fruit still lifes and architectural views of California and Europe also continued. Of the latter, *East View of Notre Dame, Paris* showed one of Deakin's best-known subjects from a new vantage point. "In making this study, Mr. Deakin left the beaten track and presented an entirely new view of the great cathedral," wrote a reviewer for the *San Francisco News Letter.* "Most pictures of Notre Dame show the front view, but this painting of the scene from the river has a charm of its own that the others do not possess."[115]

Deakin sold the painting at a December 1893 auction of his work. Held at Easton, Eldridge & Co., the sale included not only

DEAKIN'S BERKELEY STUDIO, n.d.

Unknown photographer. Collection of Marjorie Dakin Arkelian

Notre Dame, but also *Poets' Corner, Westminster Abbey, Christmas Morning,* and various other still lifes, landscapes, architectural subjects from the United States and Europe, and "outdoor studies" of Strawberry Creek. The sale was a surprising and dismal failure. *Notre Dame,* which the artist valued at $5,000, sold for only $400. Deakin withdrew other paintings, including *Poet's Corner, Westminster Abbey,* and *Christmas Morning.* "We are giving these pictures away," the auctioneer scolded. "It would be as well to throw them into the street and have done with it."[116]

Perceiving that he had saturated the market with European subjects, Deakin returned to painting California landscapes. In the summer of 1895, he journeyed to the Sierra and Lake Tahoe

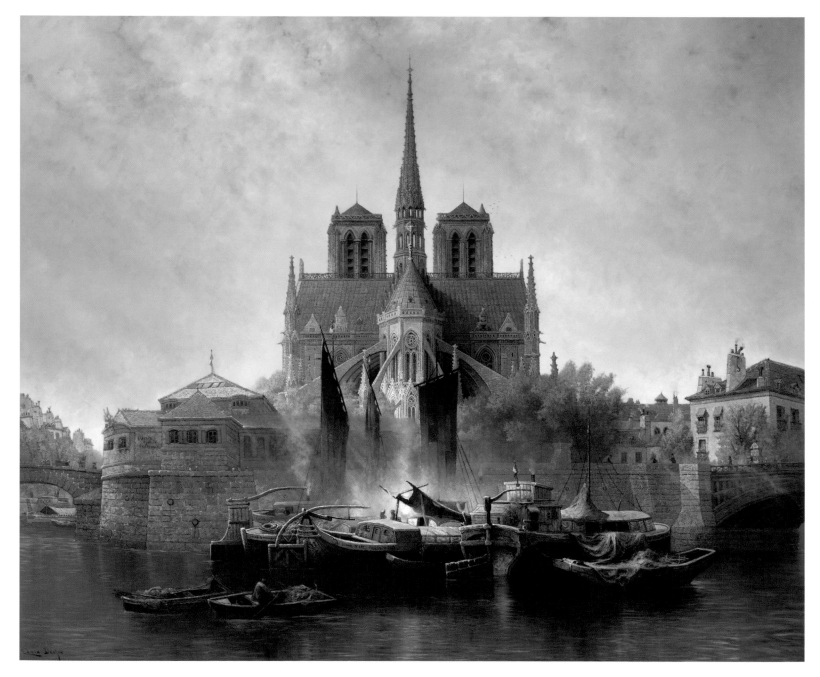

NOTRE DAME, PARIS, c. 1893

Oil on canvas, 55 1/4 x 66 1/4 in. Crocker Art Museum, long-term loan from the California Department of Finance, conserved with funds provided by Gerald D. Gordon

to sketch, exhibiting the resulting paintings at his Berkeley studio in the fall. During this period, he contributed little to exhibitions in San Francisco.[117] Floundering for direction, he also painted still lifes, but ultimately determined that he must find a new course. In November 1897 the *Chronicle* announced: "Deakin has embarked in a very important work, one which will occupy him largely for the rest of his life. He is going to undertake, under the patronage of some wealthy man, a series of works which will perpetuate for all time the California missions, fast falling into decay. He has already begun."[118]

ANCIENT and HOLY THINGS
Mission Paintings

Deakin's paintings of the twenty-one California missions would be recognized as his crowning achievement. Overall, he produced three complete series of mission paintings—two sets in oil, the other in watercolor—and many stand-alone compositions.[119] The second set of oils was smaller than the first, painted for Deakin's private gallery and meant as a safeguard against loss or damage to the originals.[120] He even designed original frames for the first set, incorporating Christian symbols such as carved thorns and nails and overlapping corners forming crosses. On the first painting in the series he transcribed again his favorite lines from Kingsley's "Old and New": "So fleet the works of men, back to the[ir] earth again; / Ancient and holy things fade like a dream."

To realize the paintings, Deakin created more than 150 preparatory drawings ranging from simple sketches to highly finished works.[121] When possible, he sketched each mission from the source, traveling to the sites by wagon. "Journey after

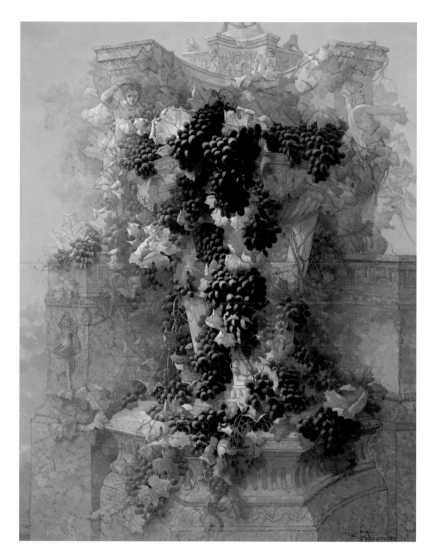

GRAPES AND ARCHITECTURE, 1896

Oil on canvas, 42 1/8 x 28 1/8 in. Crocker Art Museum, long-term loan from the California Department of Finance, conserved with funds provided by Louise and Victor Graf

journey has been made to each mission," reported Paul Shoup in *Sunset*. "Innumerable sketches have been drawn; weeks have been spent in studies of wall and tower, and every painting has had its changes to conform to some improved conception."[122] For missions greatly altered, heavily damaged, or destroyed over time, Deakin made a thorough study of what was left of the foundations and used any documentary evidence he could find to recreate them. Daguerreotypes made in the 1850s by James M. Ford aided his renderings of Missions Santa Clara and San José; and an 1876 painting by Léon Trousset informed his view of Mission Santa Cruz.[123] Deakin also acknowledged the use of Carleton Watkins's photographs of Mission San José, taken before the earthquake of 1868, and of Mission San Luis Obispo. For Mission San Rafael, he drew upon verbal accounts.[124]

The mission series was not an entirely new direction for the artist. Deakin claimed to have begun the series in 1870, his first year in the state, when he sketched and painted Mission Dolores. Other mission renderings, many executed in the mid- to late 1870s, were exhibited from time to time. Considered as a series, however, the mission paintings occupied his primary attention between 1897 and 1899.[125]

By dating his interest in the missions to 1870, Deakin competitively placed himself first among the artists who conceived of depicting all twenty-one California missions. In 1883, Henry Chapman Ford published a complete series of mission etchings that preempted Deakin's achievement. A lesser-known artist, Oriana Day, depicted all of the missions between 1877 and 1884. Deakin claimed authorship of the concept only after these artists had died. "Deakin was the originator of the idea," the *Chronicle* reported in 1897, after interviewing the artist. "He began his sketches in 1870, before the late Mr. Ford thought of it, and gave it up because Ford was a friend of his and there were other things that Deakin could do. He has always had a wish to take up the work again."[126]

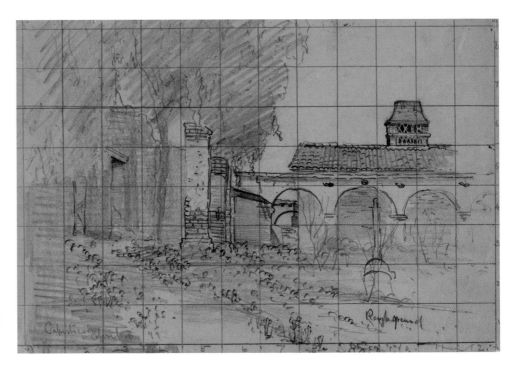

CAPISTRANO—APRIL 5, '99, 1899

Graphite on paper, 8 x 11 1/2 in. Crocker Art Museum, gift of Dr. Oscar Lemer, conserved with funds provided by Susana and Aj Watson

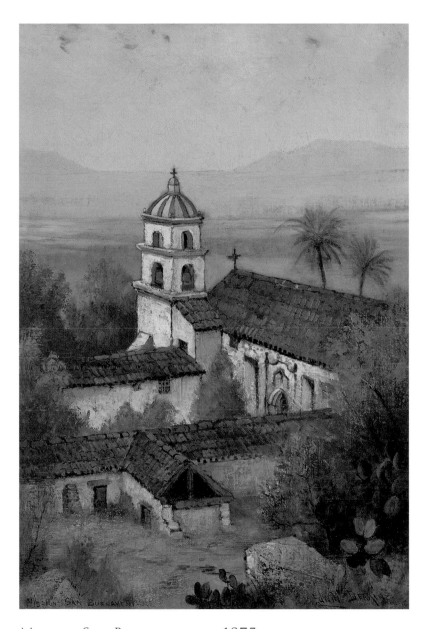

MISSION SAN BUENAVENTURA, 1875

Oil on canvas, 18 x 12 in. Collection of Joseph and
Maria Fazio, courtesy of Garzoli Gallery

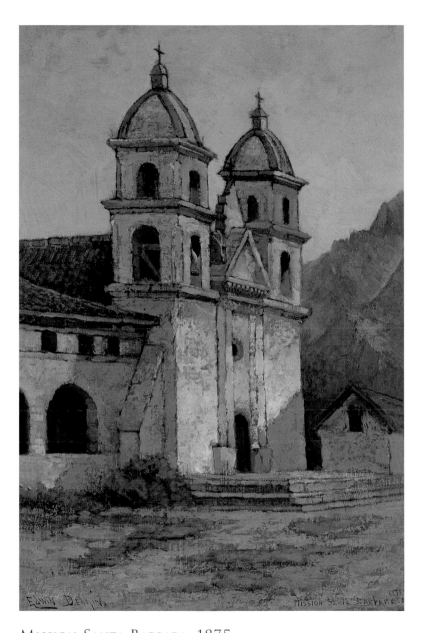

MISSION SANTA BARBARA, 1875

Oil on canvas, 18 x 12 in. Collection of Joseph and
Maria Fazio, courtesy of Garzoli Gallery

Deakin's early enthusiasm for the missions arose amid growing interest in California's Spanish heritage at the time of the United States centennial, a time when artists of the East and West looked back at the nation's origins. In the 1870s, California artists and writers began to view the state's Spanish colonial era as a noble period; this view would lead to the missions' preservation as emblems of colonial times. Elizabeth Hughes, author of *The California of the Padres; or, Footprints of Ancient Communism* (1875), blamed industrialization for a breakdown in community leading to her state's social troubles; her book urged Californians to look to the mission system as a model of industrial organization and social reform. Decrying the vulgarity of contemporary buildings, she compared the grandiose Victorian homes of San Francisco with the simple grace and spiritual dignity of adobes and mission churches, finding the soul of each society within its architecture.

Visual artists agreed with these ideas. Deakin's mission paintings in the mid-1870s, as well as his "centennial" pictures, emphasized in that time of national retrospection that American history was not to be found only to the East. Other artists portrayed similar subjects; many added a further narrative element to their works by including depictions of Father Junípero Serra founding the first California missions.

In the years around 1876, Jules Tavernier produced two paintings of the Carmel Mission and a historical scene, *Cypress Grove in Monterey One Hundred Years Ago;* Meyer Straus painted *Founding of the San Carlos Mission, Near Monterey;* and Léon Trousset painted the mission at Santa Cruz and at least three versions of Father Serra's first mass. Carl von Perbandt produced a *Landing of Junípero Serra,* and Joseph Strong brought

forth a pair of paintings depicting Father Serra's landing place and the Carmel Mission. Carleton Watkins began his extended photographic record of the missions in 1876, and William Keith sketched and painted many of the missions in the late 1870s and 1880s. Albert Bierstadt, then in the East, exhibited *Settlement of California, Bay of Monterey, 1770* at the Philadelphia Centennial Exposition in 1876; the painting later hung in the United States Capitol.

Writers, too, were fascinated. Robert Louis Stevenson wrote "The Old Pacific Capital" in 1880. Three years later, Helen Hunt Jackson's *Glimpses of California and the Missions,* and her 1884 novel *Ramona*—today often credited with focusing attention on California's vanishing heritage—contributed to Californians' understanding of their state's place in history.

Enthusiasm for the missions increased in the 1880s and beyond. At the 1893 World Columbian Exposition in Chicago, the State of California acknowledged its distinctive cultural heritage with mission-style buildings. This fascination gave rise to the widespread mission revival of the early twentieth century, a time when all California became entranced with the image of the mission and exceedingly self-conscious about promoting its past. The fashion persisted through the 1920s and was reflected in novels, histories, magazines, photographs, tourist guides, furniture, architecture, design, and art.

As subjects for paintings, California's missions and other adobe buildings reached their greatest popularity around the turn of the century, and many artists made a career of depicting them. These works offered viewers an opportunity to contemplate the profound levels of meaning that informed the buildings' obvious picturesqueness. The architect Charles Sumner Greene explained

in 1905: "The old art of California—that of the mission fathers—is old enough to be romantic and mysterious enough too. Study it and you will find a deeper meaning than books tell of, or sun-dried bricks and plaster show."[127] Deakin completed his mission series in 1899; shortly thereafter, Christian Jorgensen began a series that was ultimately realized in eighty watercolor studies and a complete set of oils. Will Sparks produced a complete set in the 1910s and another in the 1930s.

Mission paintings represent a broad effort to preserve California's rich heritage and foster an identity for the state as a whole. The missions were "visible symbols and links of tradition, joining the present with the past and supplying a glorious perspective for the future"; they had important lessons to teach about community, simplicity, faith, and working in harmony with the land.[128] These nostalgic notions ignored the harsh truth of mission life, but those who noted the discrepancy between the popular romantic interpretation and reality—such as Charles Fletcher Lummis and Mary Austin—were few. More typical was Charles Warren Stoddard's roseate haze of fantasy and dream.

> Ring, gentle Angelus! ring in my dream,
> But wake me not, for I would rather seem
> To live the life they lived who've slumbered long
> Beneath their fallen altars, than to waken
> And find their sanctuaries thus forsaken:
> God grant their memory may survive in song![129]

Mission paintings produced between the 1890s and the 1910s—and beyond—fit well with arts and crafts, or mission style, ideals, exemplifying the quest for simplicity and self-conscious rusticity championed in the arts and crafts movement's

reformative response to industrialization. Adobes and missions provided a much-needed sense of stability in a time of rapid change. "It was a careless, happy life they lived in those far-away golden days," one journalist imagined. "They were the good old days before the gringo came."[130]

For many California landscape painters, adobes and missions were among the few acceptable expressions of the human presence, a subject that achieved a balance between structure and nature. Their harmonious place within the landscape seemed directly attributable to their age. Deakin had always been interested in painting architectural landmarks, imbuing them, according to one writer, with "so strong a flavor of historic interest, that [one could] almost forget the pressure of Nineteenth century cares."[131] Rarely did Deakin paint new buildings: he favored the aged ruins of Europe, the haphazard construction of San Francisco's Chinatown, the old wooden structures left over from the early days of the American West, and Spanish adobes. "He delights in old mills, old cottages, and anything that is old," a reviewer observed, "and over which lack of care and time has thrown a romantic glamor."[132]

Artists and writers of the period widely agreed that age was essential to graceful accord between the man-made and the natural. In California, this could be no better exemplified than through the "lingering ruins of the old historic adobes overspread with grayness of age," which, the artist and curator Josephine Blanch rationalized, "harmonize[d] them with earth, sea and sky."[133] The printmaker Pedro J. Lemos expressed a similar feeling. "Excepting our old missions," he observed, "our buildings do not have the artistic oldness that is so inspiring to the etcher, and in looking around for such material, if there is any, it is

overshadowed by nature's edifices."[134] Robert L. Hewitt wrote of Deakin's paintings in 1905:

> It will readily be seen that the interest of the canvases is largely historical, and yet the crumbling condition of many of the structures and their unusual style of architecture lend them an air of the picturesque . . . and when to this is added the fact that some of these buildings date back to the middle of the eighteenth century and are stained and mellowed by time and crumbling into ruins it can easily be understood that the missions were subjects to delight the heart of a true painter.[135]

Shortly after completing the series, Deakin published a small book, *The Twenty-one Missions of California,* with a black-and-white reproduction of each painting and a brief introduction.[136] The paintings were exhibited at San Francisco's Palace Hotel the following spring. "For thirty years Edwin Deakin has been preparing the paintings of the twenty-one Franciscan missions now on exhibition in Maple Hall at the Palace Hotel," the *Chronicle* reported. "The collection is a famous one and the subjects have world-wide interest. The missions stand for the romantic period of the history of California, and travelers who know but little of this State are familiar with the beauty of these old churches and ruins of churches."[137]

The paintings were carefully installed in the hotel for maximum effect. In an otherwise dim room, each was given ample space and highlighted by state-of-the-art electric lights. As a result, each piece seemed to have an inner, indeed an almost spiritual, luminosity.

Deakin's achievement drew glowing public and critical acclaim. *Sunset* called the series the "greatest work of a California artist."[138] *The Outlook* credited Deakin, the "artist-historian," with opening the "eyes of Californians to the urgency of preserving these landmarks."[139] The *Chronicle* asserted that "Deakin's missions are distinguished by charming artistic feeling. He not only feels the missions, but he makes other people feel them, too."[140]

Deakin valued his mission collection highly, pricing it at $50,000. Many (the artist included) hoped in vain that the State of California would purchase the series for its citizens. *Sunset*'s Paul Shoup admonished his readers:

> If California . . . permits the priceless heritage that Edwin Deakin has created for her to pass from her possession, her grandchildren will not only mourn the loss but blush for the ignorance that permitted it. As I write, a party of wealthy Chicago men are raising fifty thousand dollars to buy these priceless paintings—for what?—for the University of Illinois! And proud California, wealthy California, cultured California stands idly by.[141]

As the century progressed, Deakin continued his quest to place his sets of mission paintings in public venues.[142] Although he received many offers to purchase individual works from the group, he refused to break up the set, exhibiting the paintings instead in his Berkeley studio. In keeping the series together, *San Francisco Call* critic Lucy B. Jerome remarked, Deakin "has taken a stand for which every lover of the beautiful old past should be profoundly grateful. The work has occupied him for nearly 40 years, and its monetary value is great, aside from its being the only work of its kind in existence."[143]

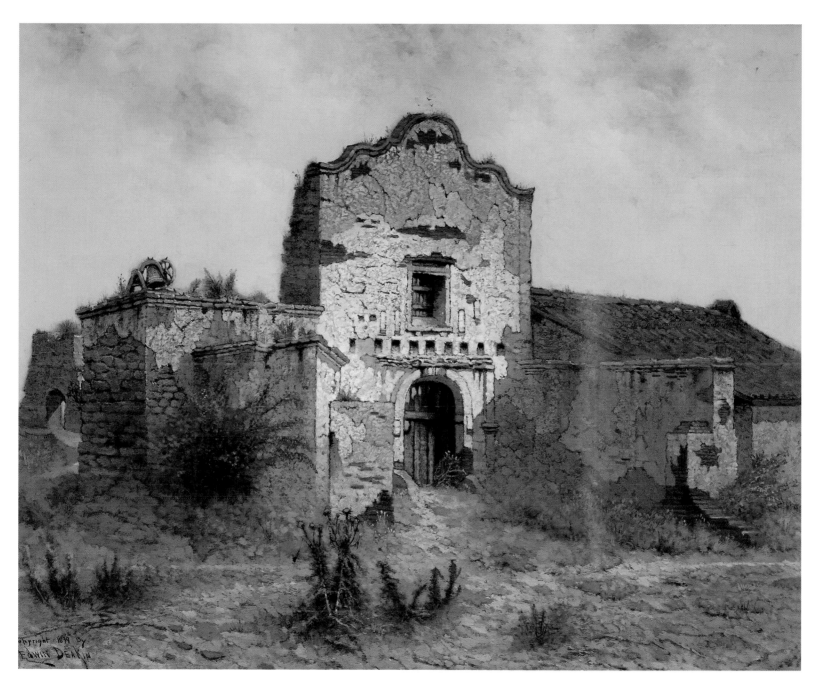

MISSION SAN DIEGO DE ALCALÁ, 1899

Oil on canvas, 25 x 30 in. Collection of the Santa Barbara Mission Archive-Library

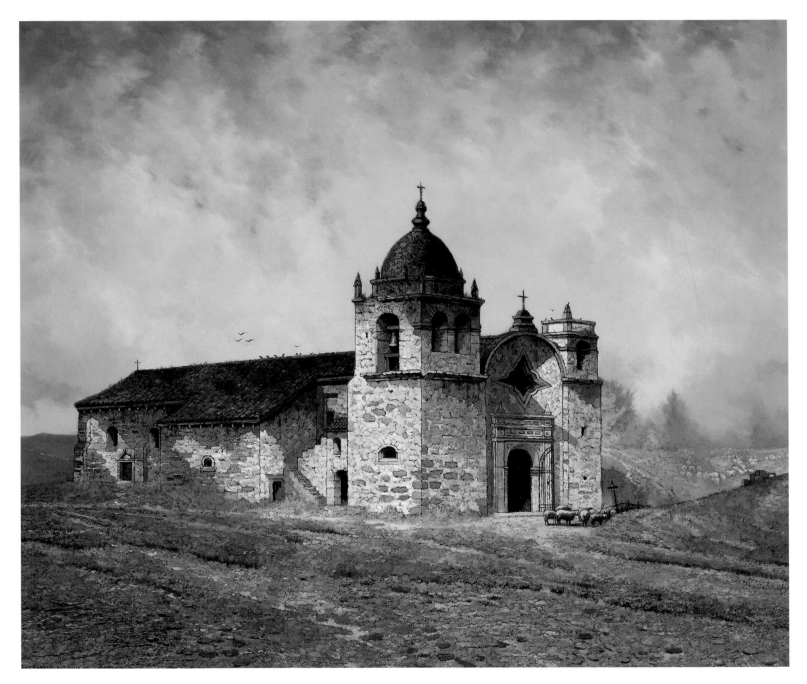

MISSION SAN CARLOS BORROMEO DEL RÍO CARMELO, c. 1899

Oil on canvas, 40 x 48 in. Collection of the Santa Barbara Mission Archive-Library

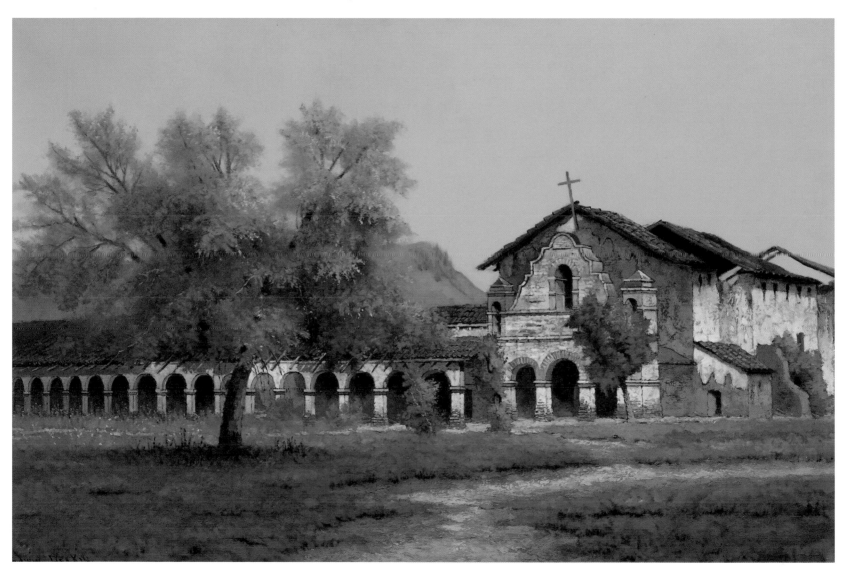

MISSION SAN ANTONIO DE PADUA, c. 1899

Oil on canvas, 24 x 30 in. Collection of the Santa Barbara Mission Archive-Library

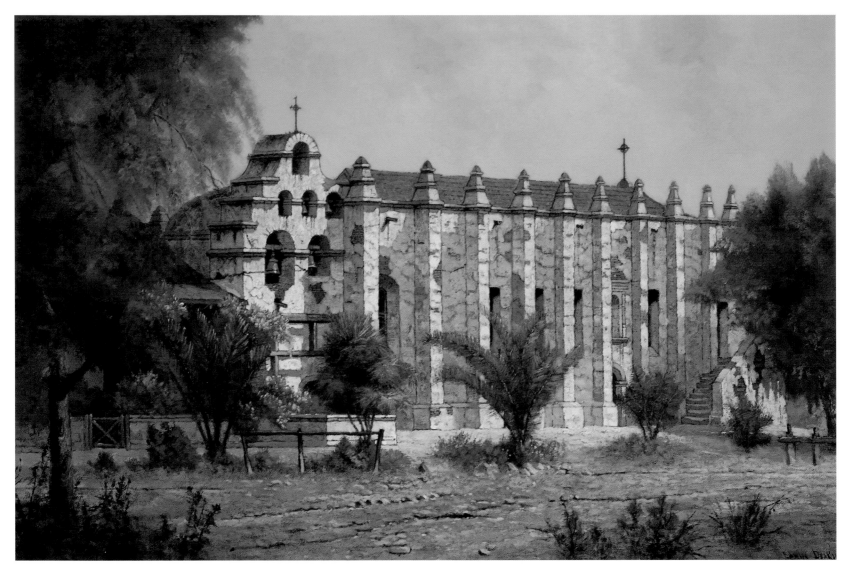

MISSION SAN GABRIEL ARCÁNGEL, c. 1899

Oil on canvas, 24 x 36 in. Collection of the Santa Barbara Mission Archive-Library

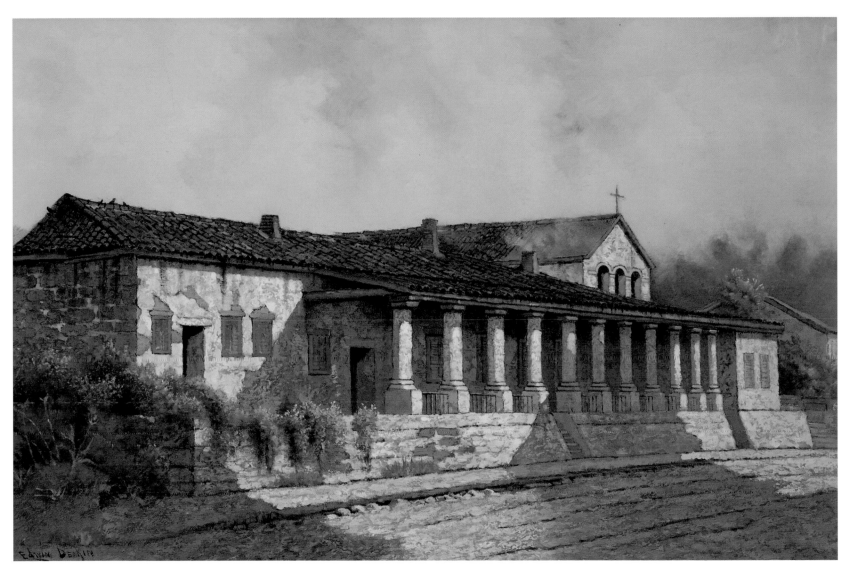

MISSION SAN LUIS OBISPO DE TOLOSA, c. 1899

Oil on canvas, 20 x 30 in. Collection of the Santa Barbara Mission Archive-Library

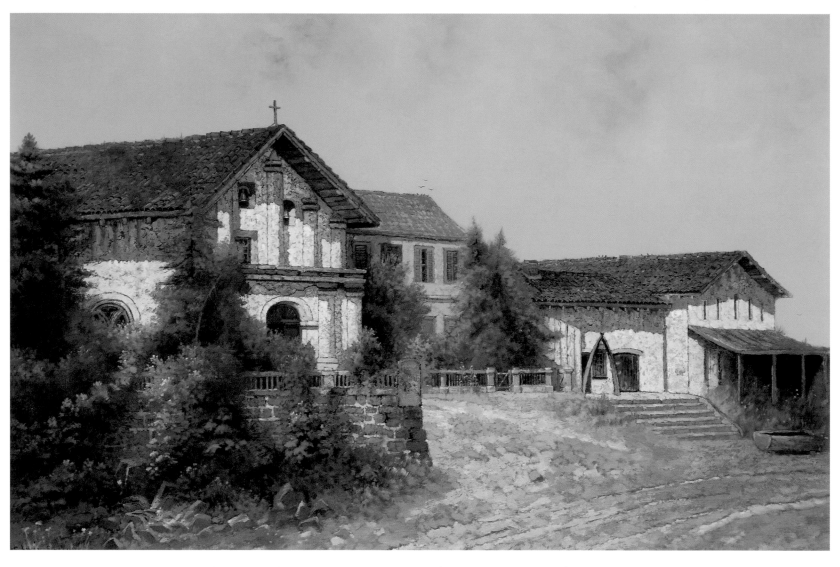

MISSION SAN FRANCISCO DE ASÍS (MISSION DOLORES), c. 1899

Oil on canvas, 28 x 42 in. Collection of the Santa Barbara Mission Archive-Library

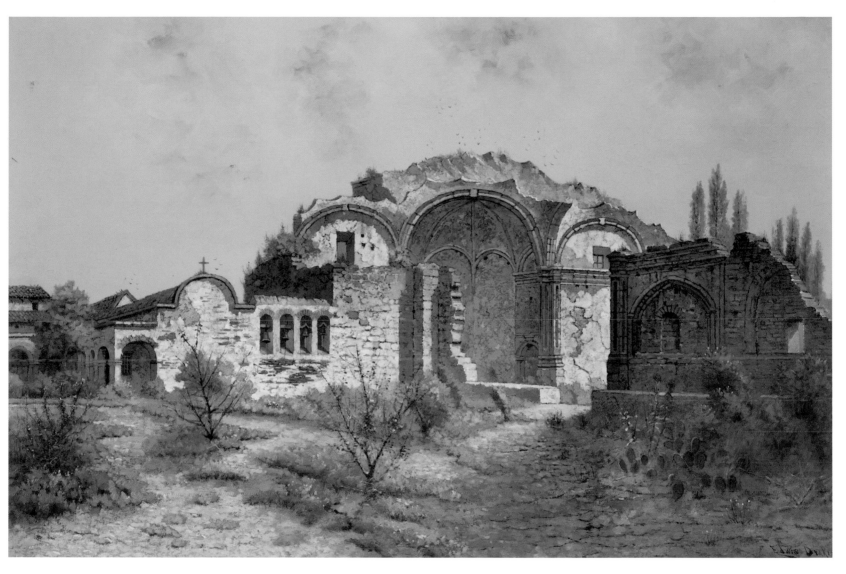

MISSION SAN JUAN CAPISTRANO, c. 1899

Oil on canvas, 28 x 42 in. Collection of the Santa Barbara Mission Archive-Library

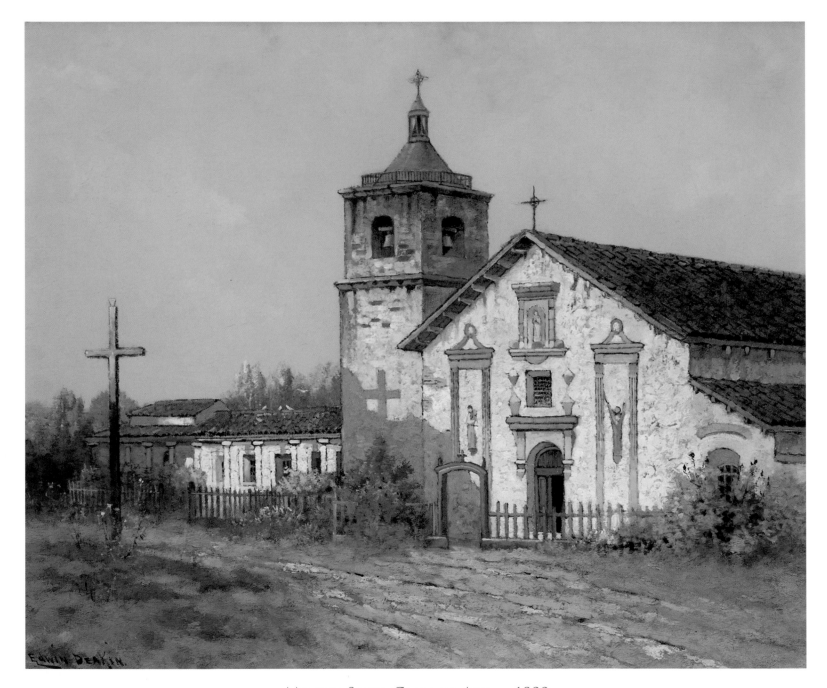

MISSION SANTA CLARA DE ASÍS, c. 1899

Oil on canvas, 20 x 24 in. Collection of the Santa Barbara Mission Archive-Library

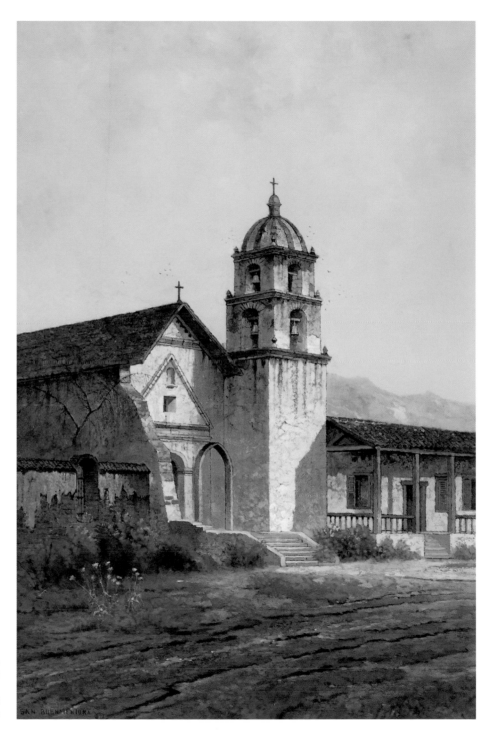

MISSION SAN BUENAVENTURA (IN 1875),
c. 1899

Oil on canvas, 42 x 28 in. Collection of the
Santa Barbara Mission Archive-Library

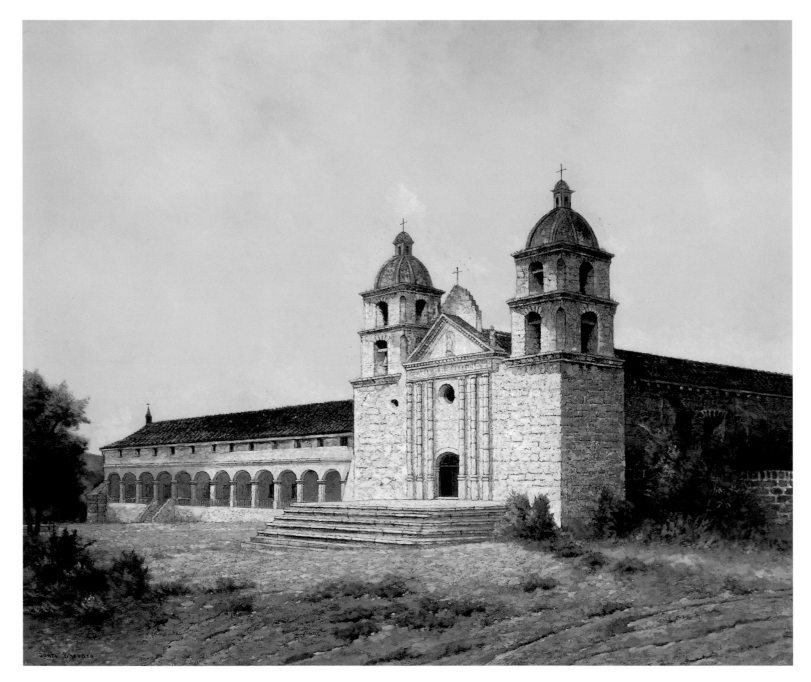

MISSION SANTA BÁRBARA, c. 1899

Oil on canvas, 40 x 48 in. Collection of the Santa Barbara Mission Archive-Library

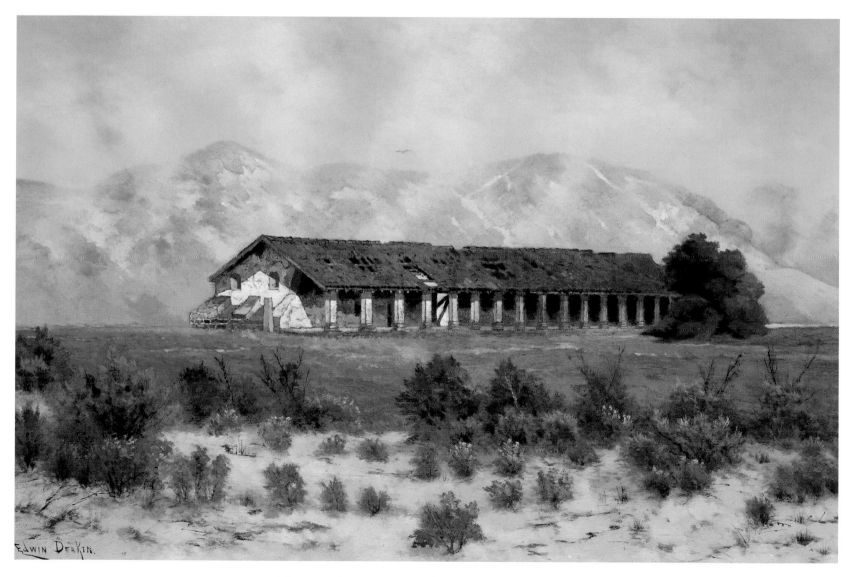

MISSION LA PURÍSIMA CONCEPCIÓN, c. 1899

Oil on canvas, 20 x 30 in. Collection of the Santa Barbara Mission Archive-Library

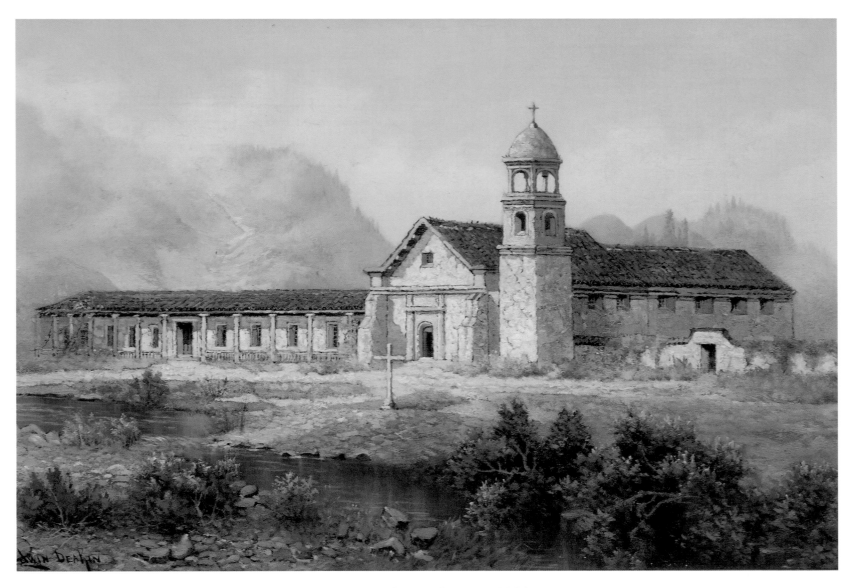

MISSION SANTA CRUZ, c. 1899

Oil on canvas, 16 x 24 in. Collection of the Santa Barbara Mission Archive-Library

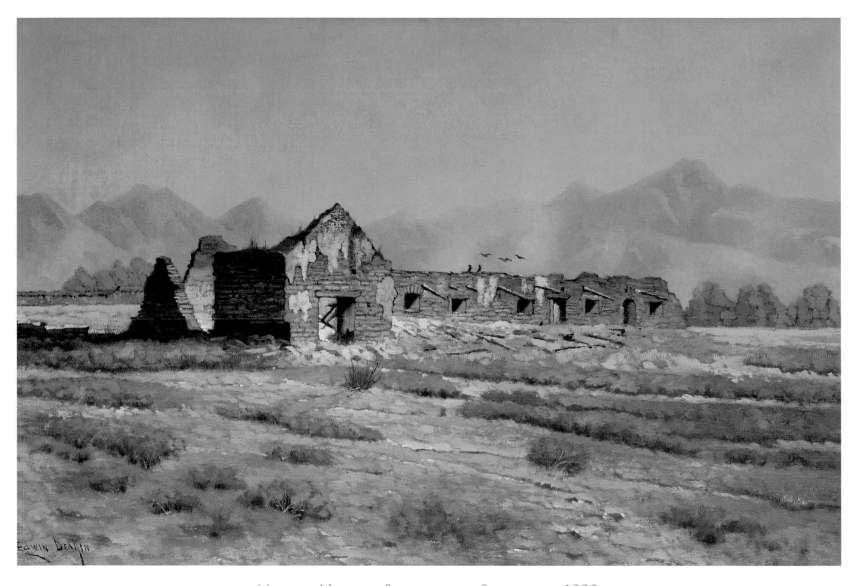

MISSION NUESTRA SEÑORA DE LA SOLEDAD, c. 1899

Oil on canvas, 20 x 30 in. Collection of the Santa Barbara Mission Archive-Library

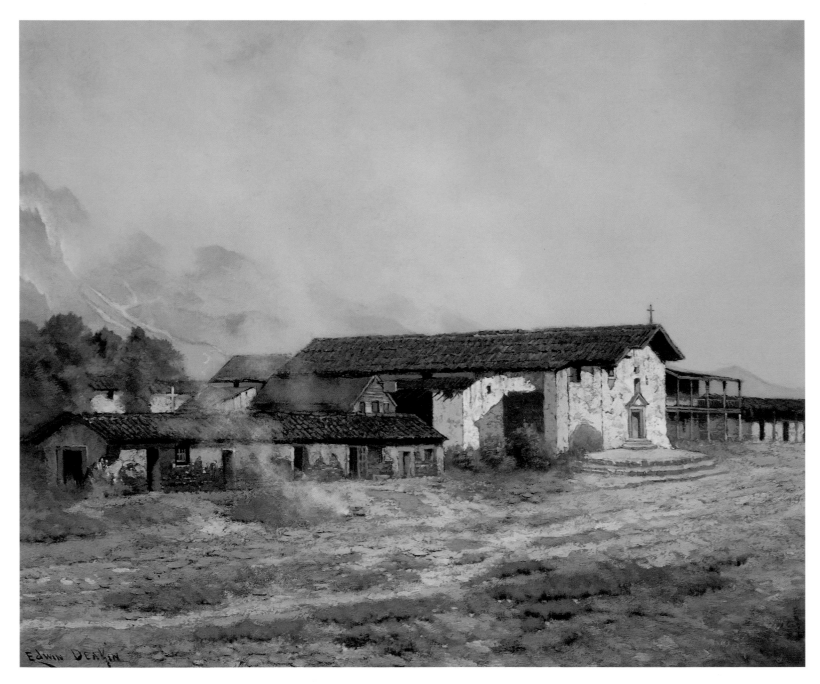

MISSION SAN JOSÉ, c. 1899

Oil on canvas, 20 x 24 in. Collection of the Santa Barbara Mission Archive-Library

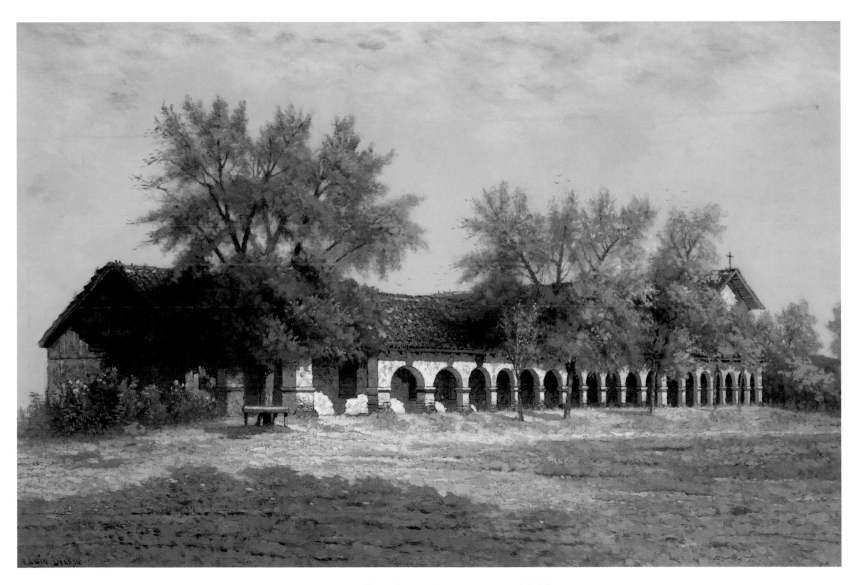

MISSION SAN JUAN BAUTISTA, c. 1899

Oil on canvas, 28 x 42 in. Collection of the Santa Barbara Mission Archive-Library

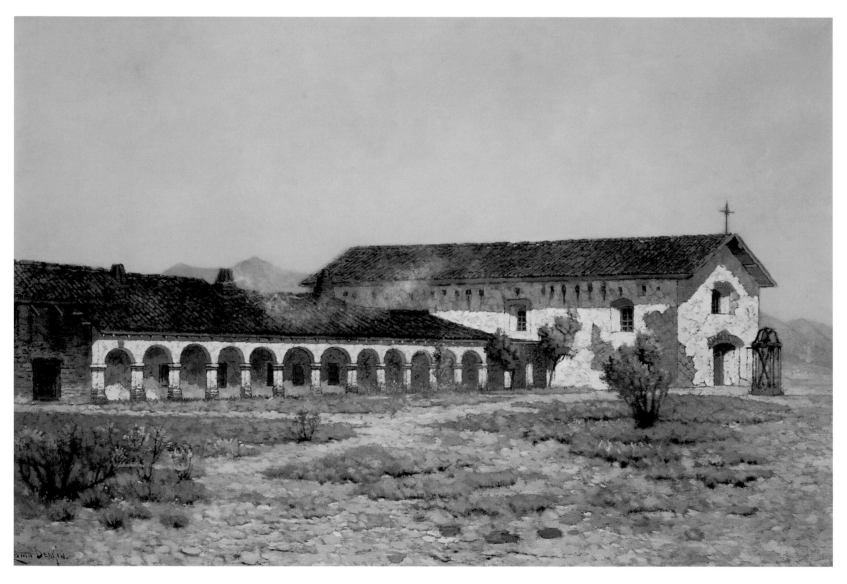

MISSION SAN MIGUEL ARCÁNGEL, c. 1899

Oil on canvas, 24 x 36 in. Collection of the Santa Barbara Mission Archive-Library

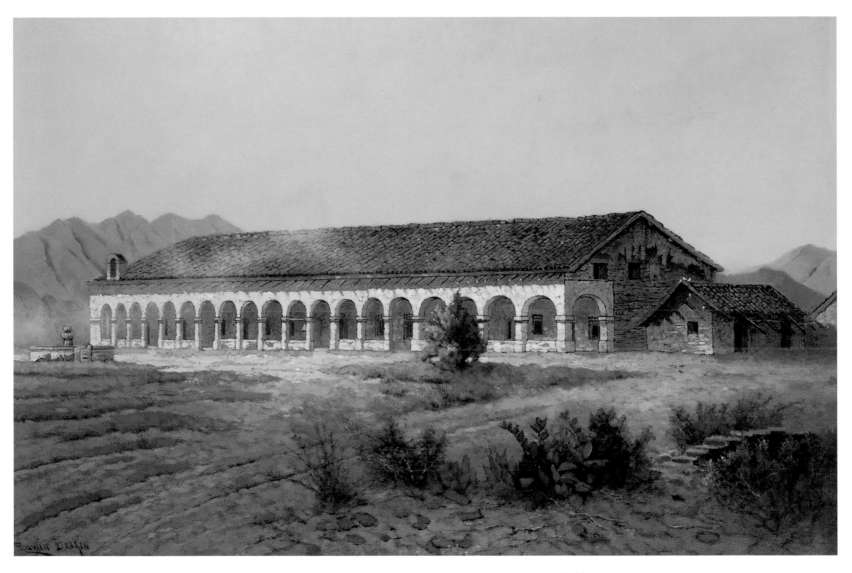

MISSION SAN FERNANDO REY DE ESPAÑA, c. 1899

Oil on canvas, 24 x 36 in. Collection of the Santa Barbara Mission Archive-Library

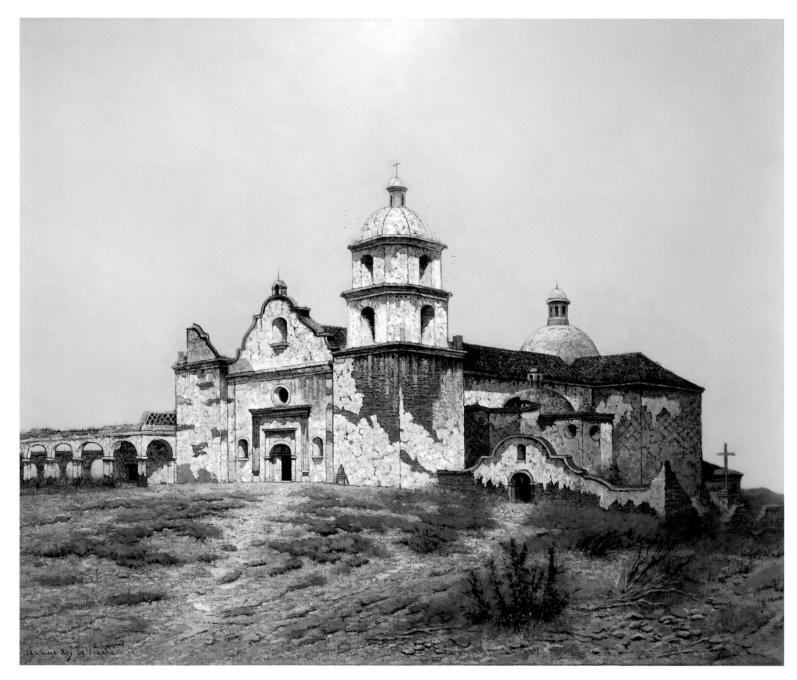

MISSION SAN LUIS REY DE FRANCIA, c. 1899

Oil on canvas, 40 x 48 in. Collection of the Santa Barbara Mission Archive-Library

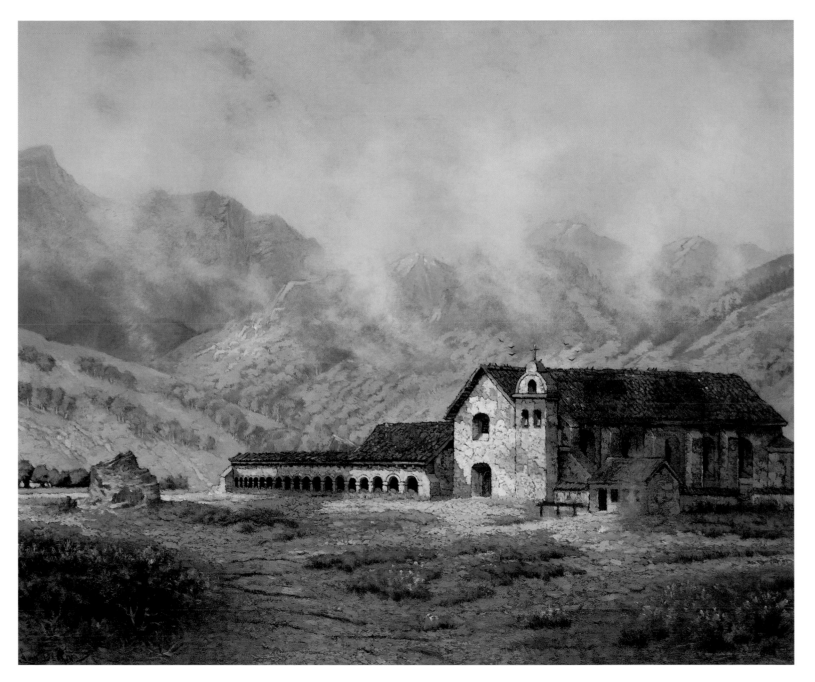

MISSION SANTA INÉS (IN 1875), c. 1899

Oil on canvas, 25 x 30 in. Collection of the Santa Barbara Mission Archive-Library

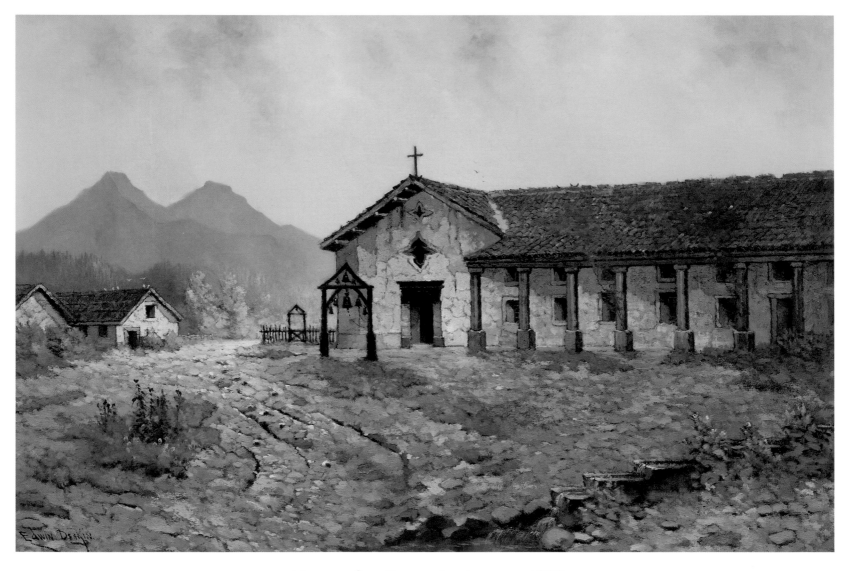

MISSION SAN RAFAEL ARCÁNGEL, c. 1899

Oil on canvas, 20 x 30 in. Collection of the Santa Barbara Mission Archive-Library

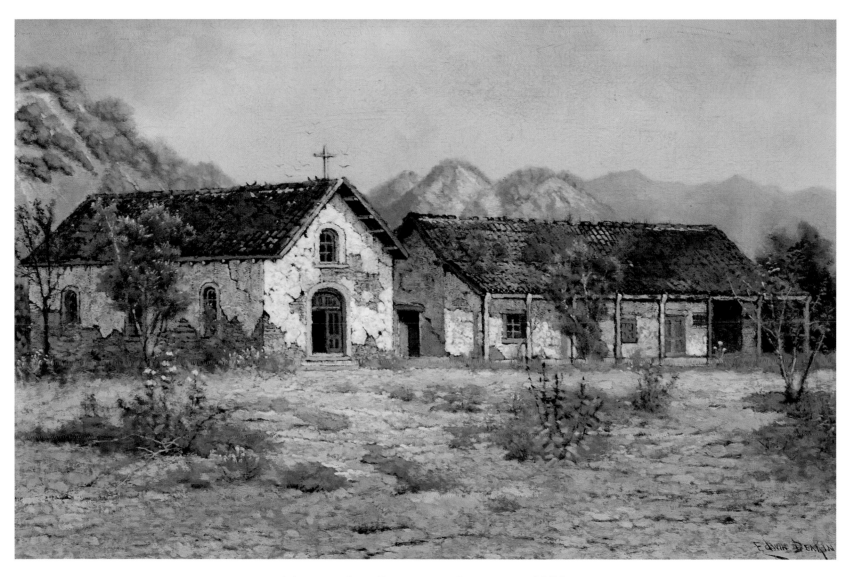

MISSION SAN FRANCISCO SOLANO, c. 1899

Oil on canvas, 16 x 24 in. Collection of the Santa Barbara Mission Archive-Library

SOUL of a STOIC
THE FINAL YEARS

On April 18, 1906, a devastating earthquake struck the Bay Area. In San Francisco, fires caused by broken gas lines and faulty wiring proved more damaging than the quake itself. Water mains were ruptured as well, and residents had few means to fight the conflagration. The city burned for three days; whole blocks of buildings were leveled by dynamite to halt the fire's spread. Nearly 30,000 buildings were destroyed and 3,000 lives were lost.

Many San Francisco collectors lost Deakin paintings in the disaster, and local artists lost hundreds, or even thousands, of their works. Deakin—with his home and studio across the bay in Berkeley—suffered less than his colleagues. As San Francisco burned, he produced nocturnal views of the city in flames. Limned from across the bay, the small, loosely painted works capture the moment with immediacy and drama.[144]

Deakin was one of many artists who depicted the city's wreckage in the months following the quake. Arnold Genthe produced a famous photographic series of the fire in progress and its aftermath by moonlight. Jack London took photographs and wrote a dramatic account, "The Story of an Eyewitness," published in *Collier's Weekly*. Mary DeNeale Morgan recorded the damage in crayon and pastels; Chris Jorgensen, Will Sparks, Charles Rollo Peters, and others rendered heart-wrenching scenes on canvas. Deakin's sketches of City Hall, Grace Church, Market Street, and other landmarks in ruins filled a notebook.[145] From these came paintings such as *Despair*, a scene showing the remains of the city from Nob Hill, the foreground buildings reduced to rubble. He also depicted what was left of specific structures, the most important for him being the city's art school, the Mark Hopkins Institute of Art. The title of one such painting—*Revival, The Terrace, Hopkins Institute of Art*—and the flowers that bloom in its foreground convey his hope for the future.

In the years that followed, Deakin continued to exhibit at his Berkeley studio and in the new Piedmont Art Gallery. He added variety to his still-life repertoire, including profuse sprays of flowers, musical instruments, and other *objets*. His basic style changed little, although passages in his late landscapes show the influence of impressionist light and brushwork. "It has been said that Deakin paints in a style of twenty years ago," Lucy Jerome of the *Call* observed, "but, putting style aside anyone who can

SKETCH—SAN FRANCISCO FIRE, 1906

Oil on canvas, 8^1/$_2$ x 11^1/$_4$ in. Oakland Museum of California, gift of Mr. and Mrs. Howard Willoughby

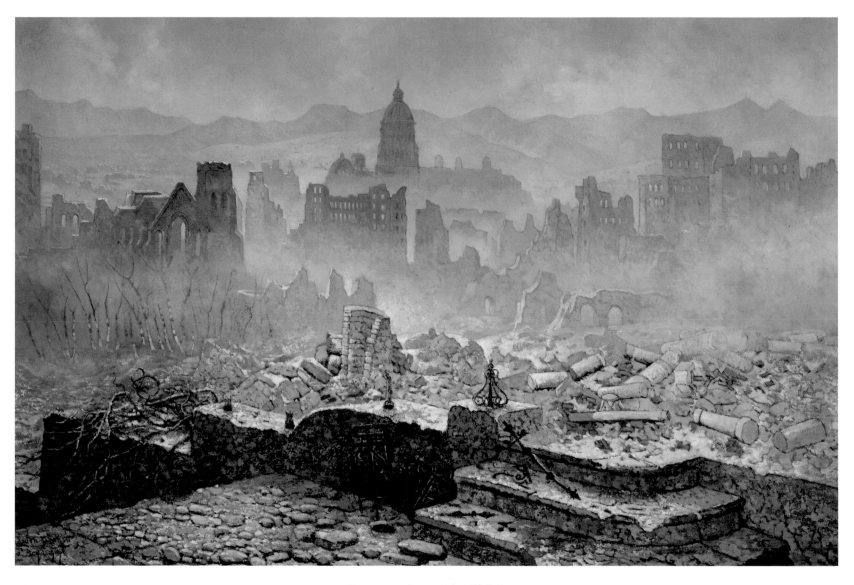

DESPAIR, JULY 10, 1906

Oil on canvas, 28 x 42¹/4 in. Oakland Museum of California, gift of Mr. and Mrs. Howard Willoughby

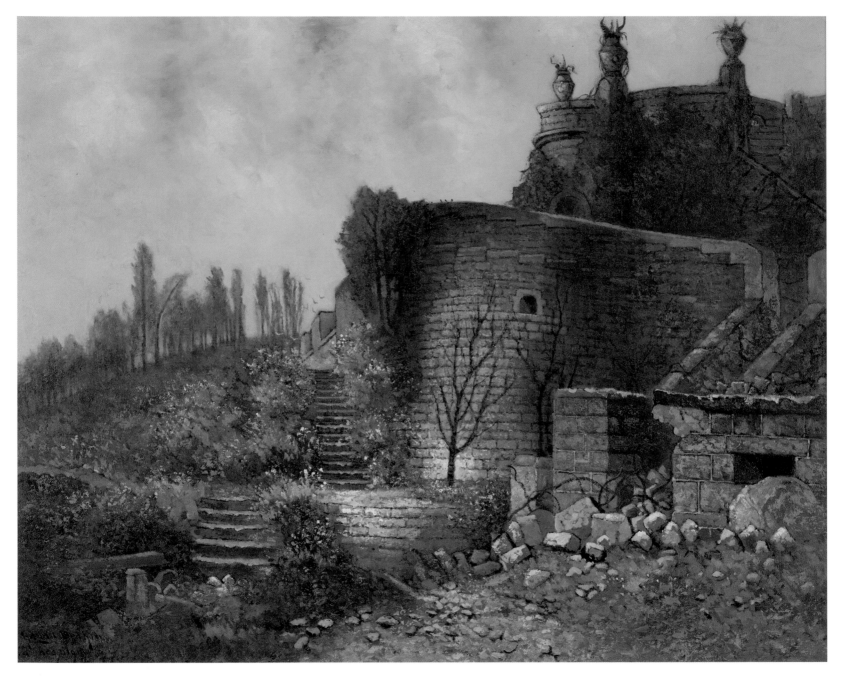

REVIVAL, THE TERRACE, HOPKINS INSTITUTE OF ART, 1906

Oil on canvas, 24¹/₂ x 30¹/₄ in. Crocker Art Museum, long-term loan from the California Department of Finance, conserved with funds provided by Louise and Victor Graf

behold the picturing of the lovely, shadowy arched missions unmoved has the soul of a stoic."[146]

At seventy-seven, Deakin found inspiration in the buildings of the 1915 Panama-Pacific International Exposition. Delighted by Bernard Maybeck's Palace of Fine Arts, he painted the subject several times after the close of the exposition. He also celebrated fifty years of marriage, presenting his wife with a small painting of golden grapes in a loving cup on their golden anniversary.[147]

By the time of the exposition, Deakin was simultaneously considered a relic of the past and the grand old man of California art. Laura Bride Powers of the *Oakland Tribune* reported:

> Nearly half a century has passed since the first organization for the advancement of art was formed in San Francisco.
>
> At that time there were very few artists on this coast, but they played an important part in developing the artistic taste of the people of their period.
>
> Among these early artists were J. B. Wandersforde [sic], Arthur Nahl, Norton Bush, Edwin Deakin, Holdridge [sic], Samuel Brooks [sic] and Ben Sears. These men gathered together as a society to improve the standard of art in San Francisco and in a social and friendly way to come into closer touch with each other. They were the sturdy pioneers who laid the foundations for serious art in San Francisco, and it was through the influence of these men and their associates that an interest in the fine arts was fostered among the wealthy residents of the city.[148]

Deakin was the only artist mentioned in the article who was still alive.

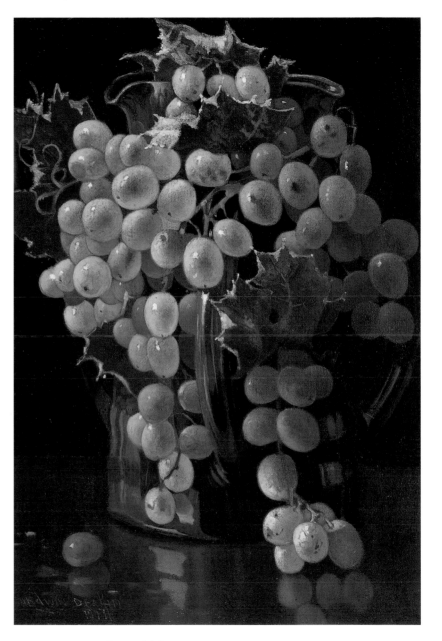

THE LOVING CUP, 1897
Oil on panel, 12 x 8 in. Private collection, courtesy of Garzoli Gallery

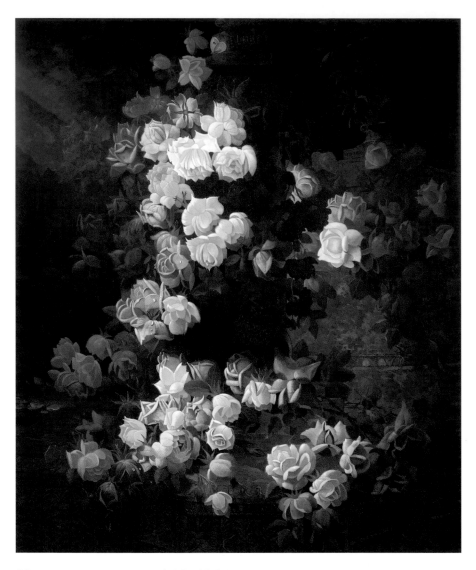

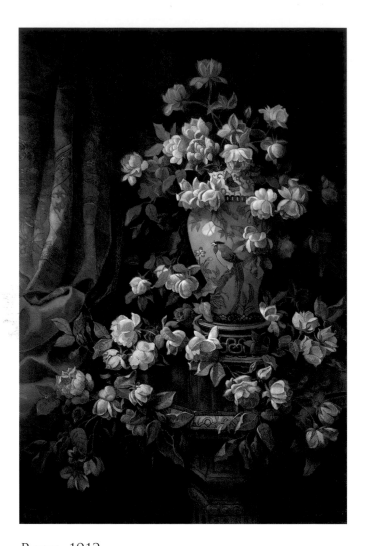

Homage to Flora, 1903–1904

Oil on canvas, 36 x 30 in. Collection of Marjorie Dakin Arkelian

Roses, 1912

Oil on canvas, 30³/16 x 20¹/4 in. Crocker Art Museum, long-term loan from the California Department of Finance, conserved with funds provided by Gerald D. Gordon

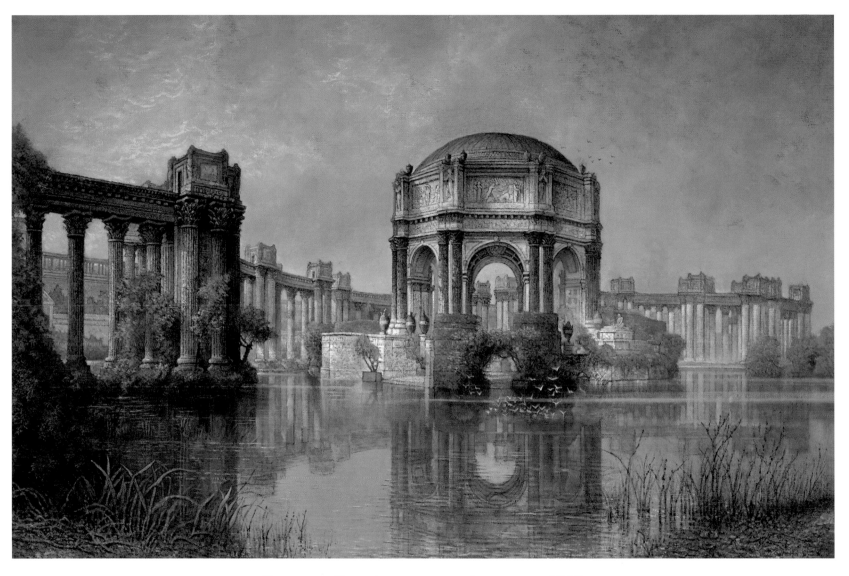

PALACE OF FINE ARTS AND THE LAGOON, c. 1915

Oil on canvas, 32³/8 x 48³/8 in. Crocker Art Museum, long-term loan from the California Department of Finance, conserved with funds provided by Gerald D. Gordon

In June 1918, Deakin held a small retrospective at his Berkeley studio. The show included Chinatown subjects; pre-earthquake views of the *Chronicle, Call,* and Ferry buildings; European subjects such as Notre Dame, Hotel Cluny, and Westminster Abbey; a series of paintings depicting the Palace of Fine Arts at the Panama-Pacific International Exposition; and several recent still lifes. Many of these paintings remained in Deakin's possession until the end of his life and then passed to his daughters.[149]

Deakin had developed arteriosclerosis; he died in Berkeley from a cerebral hemorrhage on May 11, 1923. Nearly eighty-five, he had painted almost until the end.[150] The *Chronicle* called him "the last member of a group of celebrated painters of early San Francisco days."[151] Indeed he was.

For more than half a century, Deakin painted works that defined his place and his era—paintings popular then, as now, for their quiet beauty and romance. Landscape, still life, and architecture alike, ranging from the local to the international, offered him possibilities. He explored these "picturesque bits and interesting out-of-the-way scenes" in depth and in earnest, ultimately producing a large, diverse, and historically important body of work that stands among the major achievements in early California art.

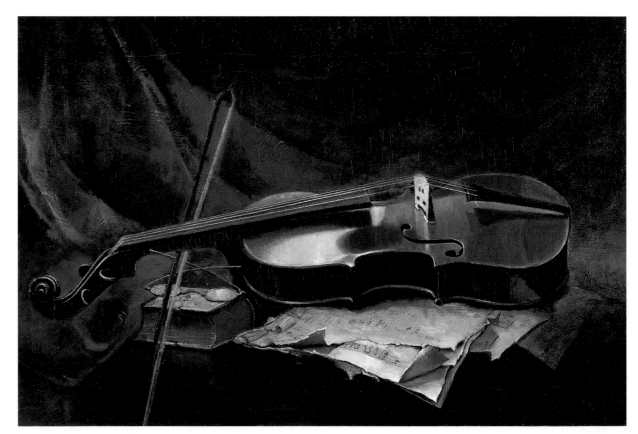

THE VIOLIN, c. 1912

Oil on canvas, 16 1/8 x 24 1/4 in.
Collection of Joseph and Maria
Fazio, courtesy of Garzoli Gallery

ENTRANCE, HÔTEL DE CLUNY, c. 1888

Oil on canvas, 36^1/$_{16}$ x 24^1/$_8$ in. Crocker Art Museum,
long-term loan from the California Department of Finance,
conserved with funds provided by Louise and Victor Graf

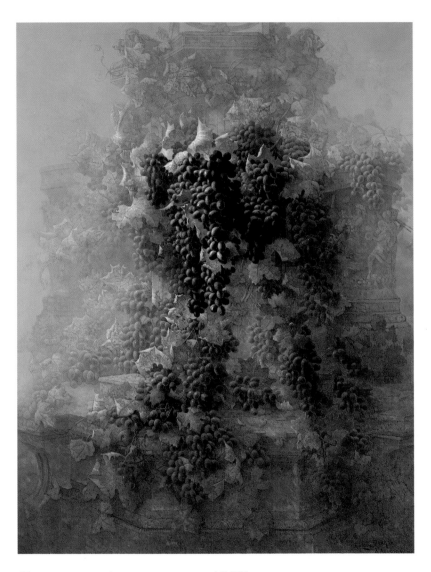

Grapes and Architecture, 1907

Oil on canvas, 42¹/₈ x 32 in. Crocker Art Museum, long-term loan from the California Department of Finance, conserved with funds provided by Louise and Victor Graf

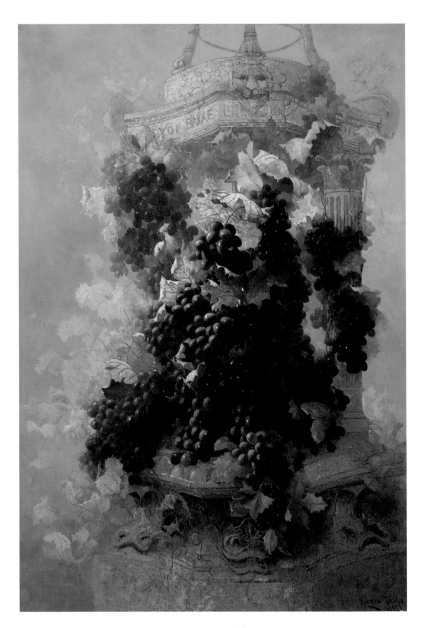

Grapes and Architecture, 1908

Oil on canvas, 48¹/₄ x 36¹/₄ in. Crocker Art Museum, long-term loan from the California Department of Finance, conserved with funds provided by Louise and Victor Graf

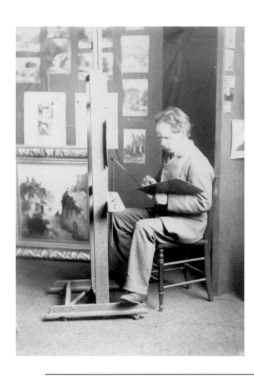

DEAKIN IN STUDIO,
c. 1895

Unknown photographer.
Courtesy North Point Gallery,
San Francisco

1. "Edwin Deakin," *Salt Lake Daily Herald,* Aug. 5, 1883.

2. Isobel Field, *This Life I've Loved* (New York: Longmans, Green, 1937), p. 139.

3. William Keith, lecture delivered to the Longfellow Society at the University of California, 1888, quoted in Raymond L. Wilson, *William Keith: A Changing Vision* (Fresno, Calif.: Fresno Art Center, 1984), n.p.

4. Pauline R. Bird, "Painter of California Missions," *The Outlook* 76 (Jan. 2, 1904), p. 77.

5. "A San Francisco Artist in Denver," *San Francisco Call,* Apr. 9, 1883 (reprint from *Denver Tribune*).

6. B., "Deakin, the Artist," *Daily Alta California,* Nov. 9, 1873.

7. His siblings were Charles (1834–1850), Albert (1836–1877), Walter (1842–1911), James Henry "Harry" (1844–?), Louisa "Lucy" (1847–?), and Frederick (1855–1917).

8. Deakin often wrote "d'Acquigny" on his later paintings, directly below his signature. This was the derivation of his family's name, meaning "from Acquigny," which evolved as follows: DeAkenys, Dakenys, Dakyns, Dakin, Deakin. Deakin's ancestors came from Acquigny, in Normandy, in the eleventh century, and the artist himself visited there during his European travels. Robert Dakin, who started the cutlery business Deakin Sons & Co., in Sheffield, changed the family name to Deakin in 1823. I thank Margaret Dakin Lumley for providing this information.

9. In 1830, Robert Deakin Sr. went to Montreal, Canada, as a salesman for the family cutlery business. He married Louisa Holroyd Williams there on Nov. 9, 1833. The couple's first two children were born in Montreal, but they returned to Sheffield in 1836. Marjorie Dakin Arkelian notes, Jan. 6, 1969, Deakin files, Oakland Museum of California.

10. In the biographical questionnaire the artist filled out for the California State Library in 1915, Deakin claimed study in London and Paris, but answered the question "With whom?" only with "From Nature." "Artist's Biographical Card," Edwin Deakin file, California History Section, California State Library, Sacramento.

11. All three Deakin children went on to creative careers themselves. Oscar Edwin (b. Indiana, 1866–1898) became an artist, exhibiting alongside his father at California State Fair exhibitions, with the San Francisco Art Association, and posthumously at the 1909 Alaska-Yukon-Pacific Exposition in Seattle; he died of tuberculosis at thirty-two. Edna (b. Illinois, 1871–1946) became an architect in Berkeley, often working alongside her uncle, Frederick H. Dakin, and cousin, Clarence Casebolt Dakin (this side of the family dropped the "e" in 1897). Dorothy (b. California, 1874–1957) became a pianist and weaver.

12. "Harry Deakin's Brother," *Evening Wisconsin,* Apr. 23, 1883 (reprint from *Denver Tribune*).

13. Caliban (Hector A. Stuart), "Local Art Gossip," *The Golden City,* Aug. 28, 1870.

14. "Art Jottings," *San Francisco News Letter and California Advertiser,* Feb. 20, 1875.

15. Peter Pallette, "Among Denver's Artists," *Denver Republican,* undated newspaper clipping. Edwin and Robert Deakin papers, Archives of American Art, Smithsonian Institution, reel no. 4201.

16. Deakin did, however, know what he liked, and purchased paintings by artists he respected. In 1874, he bought a work by Thomas Hill at auction. Edwin Deakin, quoted in "What Is Art?," *San Francisco Chronicle,* Apr. 11, 1886; "Art Notes," *San Francisco News Letter and California Advertiser,* Apr. 25, 1874.

17. Peter Pallette, "Among Denver's Artists," Edwin Deakin Scrapbook, Edwin and Robert Deakin papers, Archives of American Art, Smithsonian Institution, reel no. 4201.

18. "The Arriola Collection," *San Francisco Chronicle,* Nov. 15, 1872; "The Arriola Collection," *San Francisco Bulletin,* Nov. 26, 1872.

19. "Art Comes to Aid the Blind Narjot," *San Francisco Call,* Jan. 3, 1897.

20. "Art Notes," *San Francisco News Letter and California Advertiser,* Nov. 1, 1873.

21. "Art Jottings," *San Francisco News Letter and California Advertiser,* Mar. 31, 1877.

22. "Studio Corners," *San Francisco Examiner,* Jan. 29, 1888; "Art Items," *Daily Alta California,* Mar. 3, 1872.

23. Harry Deakin initially stayed in the Midwest, settling in Milwaukee and managing the Grand Opera House. He later joined his brothers in California. In the 1880s, the Deakin brothers Frederick, Walter, Harry, and, to a lesser degree, Edwin ran a Japanese importing business, Deakin Bros. & Co.'s, that was based in Yokohama with a retail outlet in San Francisco's Palace Hotel. In 1885, the brothers even sponsored a traveling "Japanese Village" of Japanese craftsman and their wares that was exhibited in several cities in the United States, including New York at Madison Square Garden. Hal Johnson, "So We're Told," *Berkeley Daily Gazette,* Sept. 3, 1952. Clipping with accompanying corrections by Fred. H. Dakin Jr., Deakin files, Oakland Museum of California.

24. *San Francisco Evening Post,* Sept. 19, 1872.

25. "Art Notes," *San Francisco Daily Evening Bulletin,* Nov. 9, 1872.

26. Describing the "wonders," the reporter continued, "The cataract descends nearly in the center of the picture, flanked by several of those magnificent trees, compared with which the largest arboreal giants of other quarters of the globe sink into pigmies. . . . The water, however, is the finest thing in the picture. . . . The distance is also admirably shown, and is marked by a deal of tender feeling." "Among the Pictures," *San Francisco Evening Post,* Dec. 7, 1872.

27. "In the Art Gallery," *San Francisco Bulletin,* June 21, 1872.

28. "Art Notes," *San Francisco Daily Evening Post,* Mar. 29, 1873.

29. "Local Art Notes," *The California Art Gallery,* Apr. 1873, p. 54.

30. Advertisement in the *San Francisco Chronicle,* May 18, 1873.

31. There is no surviving evidence of a European trip at this time other than the European subjects that the artist began exhibiting in the spring of 1873. These subjects were probably drawn from sketches the artist had brought from England to the United States. *San Francisco Bulletin,* May 20, 1873; *Catalogue of a Special Artist's Sale* (H. M. Newhall and Co. Auctioneers, May 21, 1873).

32. "The Art Association," *San Francisco Chronicle,* May 22, 1873.

33. "Brush and Pencil," *San Francisco Chronicle,* June 22, 1874.

34. "Knights of the Easel," *San Francisco Evening Post,* July 26, 1879.

35. "From the Easel," *Daily Alta California,* Mar. 3, 1880.

36. "Morning in the Sierras," *Daily Alta California,* Mar. 7, 1874.

37. "Art Notes," *San Francisco News Letter and California Advertiser,* Nov. 1, 1873.

38. Tahoe was the first location proposed for the Lick Observatory, but the idea had to be abandoned because deep snows would have made it inaccessible in winter. The observatory was ultimately situated on Mt. Hamilton, in the Diablo Range, east of San Jose. "Art Notes," *San Francisco News Letter and California Advertiser,* Dec. 6, 1873; "The Art Association," *San Francisco Evening Post,* Dec. 10, 1873; "Works of Art," *San Francisco Chronicle,* Dec. 21, 1873.

39. "Art Items," *San Francisco Bulletin,* Apr. 4, 1874; "Hahn's Great Painting of the Railway Station," *San Francisco Bulletin,* Apr. 11, 1874.

40. These included *Tallac Point, Lake Tahoe; Tallac Point, from Emerald Bay; The Washoe Peaks, from Donner Lake; Lake Tahoe from Island Ranch; Donner Lake at Sunset; Cataract Falls, near Yosemite;* and several sketches of Hot Springs. "Art Notes," *San Francisco News Letter and California Advertiser,* May 9, 1874; *San Francisco Illustrated Press* 2 (June 1874), n.p.

41. "Brush and Pencil," *San Francisco Chronicle,* June 22, 1874.

42. "Arts and the Drama," *San Francisco Illustrated Press* 2 (Aug. 1874), n.p.

43. According to a reporter from the *Alta,* "The tone of this painting is a great improvement in the artist's color, and the casual observer of Deakin's progress can note his steady advancement. To-day this painter has passed some of our painters who were no novices when the subject of this notice first began to paint." B., "Brevities," *Daily Alta California,* Nov. 2, 1874.

44. Hill may have purchased the painting for inventory at the Beaux Arts Gallery, in which he was a partner. "Artists' Sale of Paintings," *Daily Alta California,* Nov. 12, 1874. I thank Alfred Harrison for pointing this out.

45. "Deakin's Art Sale," *San Francisco Evening Post,* Feb. 24, 1875; "Art Notes," *San Francisco Bulletin,* Mar. 27, 1875.

46. Versions from 1876 are held by the Cantor Arts Center at Stanford University and the Fine Arts Museums of San Francisco. An 1886 version is included in the Boggs Collection, Shasta State Historical Park, California State Parks.

47. "We take it for granted that all art sharps are more or less familiar with the elegant salon occupied by S. M. Brookes, artist, on Clay street." "Art Jottings," *San Francisco News Letter and California Advertiser,* Feb. 19, 1876.

48. "The Easel," *San Francisco Evening Post,* Aug. 14, 1875.

49. The painting sold at auction for $480 at H. M. Newhall & Co. Undocumented newspaper clipping, Edwin Deakin Scrapbook, Edwin and Robert Deakin papers, Archives of American Art, Smithsonian Institution, reel no. 4201.

50. "Art Items," *Daily Alta California,* Dec. 3, 1876.

51. "Art Jottings," *San Francisco News Letter and California Advertiser,* Feb. 19, 1876.

52. "Art Jottings," *San Francisco News Letter and California Advertiser,* July 8, 1876.

53. Undocumented newspaper clipping, Edwin Deakin Scrapbook, Edwin and Robert Deakin papers, Archives of American Art, Smithsonian Institution, reel no. 4201.

54. "Art Jottings," *San Francisco News Letter,* Sept. 4, 1875.

55. "The Art Reception," *Daily Alta California,* Jan. 7, 1876.

56. "Art Notes," *San Francisco Bulletin,* Mar. 25, 1876.

57. "Art Jottings," *San Francisco News Letter and California Advertiser,* Jan. 8, 1876.

58. Caliban, *San Francisco Call,* Nov. 10, 1870.

59. "Art Notes," *Overland Monthly* (Dec. 1874), p. 574.

60. Our Local Artists," *San Francisco Chronicle,* Jan. 14, 1877.

61. B., "Art Items," *Daily Alta California,* Jan. 7, 1877, and "The Art Exhibition," *Daily Alta California,* Feb. 10, 1877.

62. "Brush and Easel," *San Francisco Chronicle,* Feb. 11, 1877.

63. "The Art Association Reception," *San Francisco Evening Post,* Feb. 9, 1877.

64. "Art Jottings," *San Francisco News Letter and California Advertiser,* Feb. 24, 1877, p. 12.

65. "Fine Arts," *San Francisco Evening Post,* Feb. 10, 1877.

66. "Sale of Deakin's Pictures," *San Francisco Evening Post,* Apr. 4, 1877.

67. "Sale of Oil Paintings," *San Francisco Chronicle,* Apr. 4, 1877.

68. "Painter and Palette," *San Francisco Chronicle,* Apr. 22, 1877.

69. "Art in Paris," *San Francisco Chronicle,* July 7, 1879.

70. "Art Notes," *San Francisco Chronicle,* Mar. 10, 1878.

71. Deakin even pasted a reproduction of Millet's self-portrait in his scrapbook. "Harry Deakin's Brother," *Evening Wisconsin,* Apr. 23, 1883 (reprint from the *Denver Tribune*); Edwin Deakin Scrapbook, Edwin and Robert Deakin papers, Archives of American Art, Smithsonian Institution, reel no. 4201.

72. "Palette and Easel," *San Francisco Chronicle,* July 6, 1879.

73. "Palette and Easel," *San Francisco Chronicle,* Dec. 8, 1879.

74. "Art Notes," *San Francisco Chronicle,* Aug. 31, 1879.

75. "The Art Gallery," *San Francisco Chronicle,* Sept. 8, 1879.

76. "Art Notes," *San Francisco Chronicle,* June 20, 1880.

77. "The Studios," *San Francisco Chronicle,* Sept. 28, 1879.

78. "Art Jottings," *San Francisco News Letter and California Advertiser,* Nov. 15, 1879.

79. "Art Jottings," *San Francisco News Letter and California Advertiser,* May 15, 1880.

80. "Deakin's Art Sale," *San Francisco Evening Post,* Feb. 24, 1875.

81. "The Art Exhibition," *San Francisco News Letter and California Advertiser,* Apr. 22, 1882.

82. "Art Notes," *San Francisco Chronicle,* May 31, 1885.

83. "Art Notes," *San Francisco Call,* Jan. 18, 1880.

84. "Art's Royal Realm," *San Francisco Evening Post,* Jan. 17, 1880.

85. "Art Jottings," *San Francisco News Letter and California Advertiser,* Mar. 13, 1880.

86. "San Francisco Art," *San Francisco Examiner,* Nov. 28, 1880.

87. "San Francisco Art," *San Francisco Examiner,* Jan. 16, 1881.

88. "Artists' Reunion," *San Francisco Post,* Mar. 22, 1881.

89. Deakin exhibited two oils, *Notre Dame* and *The Choir of Westminster Abbey,* and several sketches. "The Art Association," *Daily Alta California,* Mar. 23, 1881.

90. Deakin, quoted in "An Art Proposition," newspaper clipping, Edwin Deakin Scrapbook, Edwin and Robert Deakin papers, Archives of American Art, Smithsonian Institution, reel no. 4201.

91. "The Promises for Future Pictures," *San Francisco Examiner,* Oct. 4, 1881.

92. "The Art World," *San Francisco Post,* Oct. 8, 1881.

93. "The Art World," *San Francisco Post,* Dec. 24, 1881.

94. "A San Francisco Artist in Denver," *San Francisco Call,* Apr. 9, 1883 (reprint from *Denver Tribune*); *Denver Daily Tribune,* Nov. 12, 1882.

95. *Salt Lake Daily Herald,* Aug. 8, 1883; "Rare Art," *Salt Lake City Daily Tribune,* Sept. 20, 1883; "Art Notes," *San Francisco Chronicle,* Mar. 23, 1884; "Art Notes," *Argonaut,* Mar. 22, 1884.

96. Deakin produced multiple depictions of the blacksmith's shop and old mill at Salt Lake City. The 1894 painting (p. 55) includes horses that Deakin painted from a study by William Hahn.

97. "The Pictures," *San Francisco Evening Post,* May 3, 1884.

98. Although the painting did travel east, it was never sent to the Salon. "Local Art," *San Francisco Chronicle,* Mar. 8, 1885.

99. Midas, "The Artists," *San Franciscan,* Mar. 21, 1885.

100. Clifford Cox, "The Art Exhibition," *Wasp,* Apr. 18, 1885.

101. Midas, "The Artists," *San Franciscan,* Apr. 18, 1885. Later Deakin paintings of San Francisco's Chinatown now bear this same title.

102. "The Art Exhibition," *San Francisco Chronicle,* Apr. 19, 1885.

103. Fingal Buchanan, "Art Notes," *San Franciscan,* Sept. 26, 1885.

104. "Brush and Palette," *San Francisco Chronicle,* Apr. 15, 1888.

105. "The Art Gallery," *Sacramento Daily Record Union,* Sept. 13, 1888.

106. "Art and Artists," *San Francisco Chronicle,* Mar. 10, 1889.

107. Deakin appreciated Dickens's writing; there are multiple newspaper clippings concerning Dickens in the artist's scrapbook. Edwin Deakin Scrapbook, Edwin and Robert Deakin papers, Archives of American Art, Smithsonian Institution, reel no. 4201.

108. "Art and Artists," *San Francisco Chronicle,* Mar. 10, 1889.

109. Deakin wrote "Grays [sic] Elegy." He exhibited the painting, along with *She Will Come Tomorrow* and a richly colored *Study of Plums,* at the 1889 California State Fair. "State Fair," *Sacramento Daily Record Union,* Sept. 15, 1889.

110. Perhaps not coincidentally, these same lines could be found inscribed on the old walls of the San Diego mission. Paul Shoup, "An Old Story in Crumbling Walls," *Sunset* 4 (Apr. 1900): 244.

111. "I had finished and placed on exhibition a painting called the 'Thames Embankment.' Hardly a week had passed when one day I chanced to pass an 'art-dealer's' store. There in the window was my picture—that is, a copy or at least an attempted copy. The 'artist' had placed the church of Notre Dame on one side and bridged the river with a structure that might have passed for the Brooklyn bridge. Down on one side of the Thames he had painted a row of trees in bright green, passing under the bridge was a sail boat painted in all the colors of the rainbow. This was the last straw. I went into those 'art-rooms' and asked for the 'artist's' name. Of course I did not get it. The picture

112. "Art and Artists," *San Francisco Chronicle,* Sept. 22, 1889.

113. Deakin, quoted in "The Pirates of Art," *San Francisco Examiner,* Oct. 18, 1889.

114. Paul Mills, "Edwin Deakin, 1838–1923," in Ruth Mahood, ed., *A Gallery of California Mission Paintings* (Los Angeles: The Ward Ritchie Press, 1966), p. 16.

115. Deakin produced more than one version of this large painting. The reviewer's description matches the painting on long-term loan to the Crocker Art Museum from the California Department of Finance. However, the painting is not the same work as the one now held by the Crocker Art Museum. Shortly after completion, Deakin sold the painting at the December 1893 auction of his work to a woman from Oakland. Deakin kept the painting now held by the Crocker until the end of his life, leaving it to his daughter, who willed it to the California Department of Finance. A painting identical in subject and scale to the Crocker painting sold at Sotheby's, New York, in March 1999, making it clear that Deakin painted multiple examples. "Edwin Deakin's Painting," *San Francisco News Letter and California Advertiser,* Jan. 28, 1893.

116. "The Deakin Sale," *San Francisco Call,* Dec. 8, 1893.

117. Deakin did contribute to the 1897 opening of the new art gallery in Golden Gate Park. "Today the New Art Gallery of the Park Museum Will Be Thrown Open to the Public," *San Francisco Chronicle,* Oct. 2, 1897.

118. "Holiday Hours in Artists' Studios," *San Francisco Chronicle,* Nov. 28, 1897.

119. The first set of paintings, the watercolors, and a scrapbook of mission drawings are in the collection of the Natural History Museum of Los Angeles County. The second set is owned by the Franciscan Friars of California and held by the Santa Barbara Mission Archive-Library.

120. Letter from Edna Deakin, Carmel, Calif., to Milton Ferguson, Sacramento, Calif., Nov. 20, 1929. Edwin Deakin file, California History Section, California State Library, Sacramento.

121. Most of these drawings are in a scrapbook held by the Natural History Museum of Los Angeles County.

122. Paul Shoup, "An Old Story in Crumbling Walls," *Sunset* 4 (Apr. 1900): 244.

123. At the bottom of a drawing of the Santa Clara mission, Deakin wrote: "Santa Clara mission from a Daguerreotype about 1854. By a man named Ford." Charlotte Rabbitt Jennings, "Edwin Deakin's Scrapbook of His Sketches of the California Missions" (M.A. thesis, University of California, Santa Barbara, 1978), pp. 43–44, 64.

124. Robert L. Hewitt, "Edwin Deakin, An Artist with a Mission," *Brush and Pencil* 15 (Jan. 1905), typescript in Deakin files, Oakland Museum of California.

125. Jennings, "Edwin Deakin's Scrapbook of His Sketches of the California Missions" (M.A. thesis, University of California, Santa Barbara, 1978), p. 51.

126. "Holiday Hours in Artists' Studios," *San Francisco Chronicle,* Nov. 28, 1897.

127. Charles Sumner Greene, quoted in Timothy J. Andersen, Eudorah M. Moore, and Robert W. Winter, eds., *California Design, 1910* (Pasadena: California Design Publications, 1974), p. 96.

128. Michael Williams, "The Founder of California," *Sunset* 31 (Nov. 1913): 949.

129. Charles Warren Stoddard, *In the Footprints of the Padres* (San Francisco: A. M. Robertson, 1901), p. vii.

130. Leonore Kothe, "In Old Monterey," *Overland Monthly* 57 (June 1911): 636.

131. "Art Notes," *Denver Republican,* Oct. 15, 1882.

132. "Art Exhibition," *Salt Lake Daily Herald,* Aug. 9, 1883.

133. Josephine M. Blanch, "The Del Monte Art Gallery," *Art and Progress* 5 (Sept. 1914): 389.

134. Pedro J. Lemos, "California and Its Etchers—What They Mean to Each Other," in Antony Anderson et al., *Art in California* (San Francisco: R. L. Bernier, 1916; reprinted, Irvine, Calif.: Westphal Publishing, 1988), p. 114.

135. Robert L. Hewitt, "Edwin Deakin, An Artist with a Mission," *Brush and Pencil* 15 (Jan. 1905), typescript in Deakin files, Oakland Museum of California.

136. The first edition was published in 1899, the year Deakin finished the series. Four subsequent editions were published between 1900 and 1902.

137. "Local Exhibitions of Unusual Interest," *San Francisco Chronicle,* Apr. 6, 1900.

138. Shoup, "An Old Story in Crumbling Walls," *Sunset* 4 (Apr. 1900): 244.

139. In fact many of the missions had been, or were already being, restored. Pauline R. Bird, "Painter of California Missions," *The Outlook* 76 (Jan. 2, 1904), pp. 74, 80.

140. "Holiday Hours in Artists' Studios," *San Francisco Chronicle,* Nov. 28, 1897.

141. Shoup, "An Old Story in Crumbling Walls," *Sunset* 4 (Apr. 1900): 244–245.

142. Deakin did not live to see the mission paintings placed in a public setting. Upon his death the collection went to his daughters, who sought to fulfill their father's wishes by selling both sets of oils to the State of California in 1929 (letters from Edna Deakin, Carmel, to Milton Ferguson, Sacramento, Nov. 20 and 28, 1929, Edwin Deakin file, California History Section, California State Library, Sacramento). The sale was not realized, and in 1930 the Deakin sisters loaned the first set of mission paintings to what was then the Los Angeles Museum of History, Science and Art (today the Natural History Museum of Los Angeles County). In 1947, a bill was presented to the California State Senate Finance Committee in an attempt to purchase the paintings still on loan to the Natural History Museum, but it failed to pass. The Natural History Museum began trying to acquire the paintings in the mid-1950s; through the efforts of the museum's membership organization, the Museum Alliance, and with the assistance of Mr. and Mrs. Howard Willoughby, collectors of Deakin's work, the museum purchased the paintings from Deakin's nephew, Robert Deakin, for its permanent collection in 1959. The museum held an exhibition in 1960 featuring the mission series and other works, the first one-man museum exhibition of Deakin's work since his death.

 The Willoughbys purchased the second set of paintings and donated them in 1955 and 1956 to the Franciscan Friars of California with the provision that the collection never be broken up or sold and that the paintings be displayed at the Santa Barbara Mission.

143. Lucy B. Jerome, "Artists Return with Inspiration from Study in Mountains and Shore," *San Francisco Call,* July 12, 1908.

144. Mills, "Edwin Deakin, 1838–1923," in Mahood, p. 16.

145. Today in the collection of the Oakland Museum of California.

146. Lucy B. Jerome, *San Francisco Call,* July 12, 1908.

147. The back of the painting is inscribed "Belle from Edwin, Golden Wedding Day, Monday June 21st 1915; Wednesday June 21st 1865—Monday June 21st 1915; The Loving Cup Study from Nature by Edwin Deakin, 1897."

148. Laura Bride Powers, "Art," *Oakland Tribune,* Mar. 10, 1918.

149. Dorothy Deakin willed several of the paintings to the State of California. They were placed on long-term loan to the Crocker Art Museum in 2006.

150. Seriously ill at the time of her husband's death, Isabel Deakin died, aged seventy-seven, in Berkeley on May 6, 1924.

151. "Art Colony Loses Noted Painter," *San Francisco Chronicle,* May 27, 1923.

BIOGRAPHICAL CHRONOLOGY

Shyra McClure and Scott A. Shields

1838 May 21: Edwin Deakin born in Sheffield, England, to Robert Deakin and Louisa H. Williams; third of seven children

1850 Apprentices in japanning (decorative lacquering) of furniture

1856 Family immigrates to the United States, settling in Chicago

1857 Begins hand-coloring photographs and working as a case-maker

1865 June 21: marries Isabel "Belle" Fox in Chicago

1866 First of three children, son Oscar Edwin, born in Indiana

1867 Begins professional art career

c. 1870 Exhibits first painting, of an old English tavern, at the Crosby Art Gallery of the Crosby Opera House in Chicago; becomes a member of the Chicago Academy of Design

1870 Spends summer and fall in San Francisco; displays work in local exhibitions

Sketches Mission Dolores, his first California subject other than landscapes

November: Exhibits painting of Mission Dolores at the Snow and Roos gallery

1871 Returns to Chicago

Summer: Second child, Edna Isabel, born in Illinois

Losses in the Chicago fire prompt Deakin to return to San Francisco, where he takes a studio on Clay Street

1872 May: Exhibits landscapes of Illinois, the San Francisco Bay Area, and along route of the Central Pacific Railroad at the gallery of M. D. Nile

June 18: Contributes landscape scenes to the San Francisco Art Association's first exhibition, featuring work by its members, held at 313 Pine Street

Summer: Travels to Chicago

October: Sketches at Lake Tahoe

Appointed to Art Association committee soliciting art to raise funds for the family of recently deceased artist Fortunato Arriola

November: Travels to Yosemite with Benoni Irwin, Thomas Ross, and Hiram Reynolds Bloomer

Opens studio at 432 Montgomery Street

1873 Joins the Bohemian Club and the Graphic Club

May: Exhibits fifty-one pictures, mainly landscapes and other studies from nature, through the auctioneers H. M. Newhall & Co.

Begins advertising himself as a landscape painter; opens new studio on Montgomery Street

September: Leaves for a sketching tour of the Lake Tahoe region

October: Visits Cascade Lake and the Truckee River, producing fifty-five oil sketches from these trips

1874 Third child, Dorothy Holroyd, born in California

February: Sells several paintings at a multi-artist auction through H. M. Newhall & Co.

Plans sketching tours to the California missions, Lake Tahoe, Donner Lake, and Yosemite

July: Embarks on sketching tour to the Sierra and Yosemite

November: Contributes several paintings to an auction at H. M. Newhall & Co.; Thomas Hill purchases Deakin's *Fallen Leaf Lake* for $160

1875 Sketches Mission San Buenaventura and Mission Santa Ines

February: Offers seventy-one works in a solo auction at H. M. Newhall & Co.

March: Embarks on a Southern California sketching tour with William Hahn

July: Appointed to the art committee for the Mechanics' Fair exhibition; contributes two paintings: *Wasatch Mountains, Utah* and *Fallen Leaf Lake*

August: Plans paintings for the upcoming American Centennial

Begins sharing a Clay Street studio space with Samuel Marsden Brookes

With Brookes, makes several sketching trips around the San Francisco Bay, Lake Tahoe, and Yosemite

November: Sells paintings in a group auction at H. M. Newhall & Co.

1876 Completes first version of *Artist's Studio,* a scene of Brookes at his easel

Begins work on the six-by-ten-foot *Mount Shasta from Castle Lake*

December: Completes *Mount Shasta;* submits fifteen works to an artists' sale at H. M. Newhall & Co.

1877 March: Holds "farewell sale" of sixty-three paintings at H. M. Newhall & Co. to raise funds for extended European trip

May: Leaves for Europe

Visits Switzerland, Germany, and France, sketching mountains, lakes, and architectural subjects

July: Travels to London; sketches cathedrals and churches including Westminster Abbey and Stoke Poges

1878 Sketches and paints in Paris, visiting the Louvre, Notre Dame, and Hôtel de Cluny

1879 *Mont Blanc* and *Église de Chelles* accepted for the 1879 Salon

May: Returns to San Francisco; resumes work in Clay Street studio and turns to painting architecture

August: Completes first major painting since return from Europe: *Castle of Chillon at Lake Geneva*

Exhibits at the California State Fair in Sacramento

1880 February: Starts a relief fund, with other members of the San Francisco Art Association, for artists in crisis

April: Exhibits several paintings with The Artists' League

September: Takes an extended trip to Chicago and Milwaukee, exhibiting in both cities and selling more than thirty paintings

Late fall: Completes a large painting of Notre Dame

1881 January: Leaves on a trip to New York

March: Appointed to the "rejection committee" for the Art Association's sixteenth exhibition

Begins making plans to relocate to New York

September: Holds sale of paintings to raise funds for New York trip

Opens studio in Cincinnati

1882 Summer: Moves with family to Denver; opens studio in the "Studio Flat" located on the fifth floor of the Tabor Grand Opera House; begins painting still lifes featuring grapes, peaches, apples, and plums

1883 July: Travels from Denver to Salt Lake City; exhibits work and produces numerous drawings and oil sketches

Sells painting to the governor of Colorado, James B. Grant

By November: returns to San Francisco

1884 Relocates from Sutter Street to Clay Street studio formerly shared with Brookes

Shows *Flaming Tokay Grapes, Sweet Water Grapes,* and *Cornichon Grapes* in the San Francisco Art Association's spring exhibition

August: Contributes twenty-nine paintings to the Mechanics' Institute exhibition

Begins planning rotary exhibition of work by San Francisco–based artists but abandons the idea as too time consuming

Fall: Begins *An Offering to Bacchus,* considered one of the most ambitious fruit studies ever painted in the city

October: Offers eighty paintings at auction, realizing nearly $5,000; a Chinatown parade, seen with a number of colleagues, inspires a new artistic direction

1885 Exhibits three works, including *Street in Chinatown,* in the Art Association's spring exhibition

Visits New York at year's end

With his brothers Frederick, Walter, and Harry, sponsors a traveling "Japanese Village" of Japanese craftsman and their wares

1886 Returns to San Francisco; continues work on Chinatown scenes and still lifes of grapes

Holds auction at Easton & Eldridge of more than one hundred paintings, sketches, and studies

Paints another version of Samuel Marsden Brookes in his studio and several new Chinatown scenes

Exhibits five paintings at the California State Fair in Sacramento and wins a silver medal for "Best Fruit Piece"

December: Leaves for an extended trip to New York

1887 June: Returns to San Francisco and rents a studio at 728 Montgomery Street

Wins California State Fair's grand prize—a gold medal and $50—for most meritorious display of oil paintings by a resident California artist

1888　June: Travels to Europe, spending six weeks in London, Paris, and surrounding areas

By August: Returns from Europe; begins painting European subjects, including *She Will Come Tomorrow*

September: Exhibits thirty-three paintings at the California State Fair; they are auctioned at close of fair

1889　Spring: Sends *She Will Come Tomorrow* to New York for exhibition; shortly thereafter, visits New York himself

April: Travels to Denver

June: Returns to San Francisco

Continues to produce landscapes and fruit still lifes from sketches made in the East and in Europe

1890　Purchases a part of the Peralta Estate in Berkeley; builds a mission-style home and studio at 3100 Telegraph Avenue, where he will live the rest of his life

Continues painting local scenes around Berkeley, fruit still lifes, and architectural views of California and Europe

1893　December: Offers work at auction held at Easton, Eldridge & Co. Sale is unsuccessful; Deakin withdraws some paintings

1894　Returns to painting California landscape

1895　Summer: Takes a sketching trip to the Sierra and Lake Tahoe region

Fall: Exhibits the paintings produced from the trip at his Berkeley studio

1897　Begins work on his series of twenty-one California missions

1898　Mission series continues to occupy Deakin's primary attention

Deakin's son, Oscar, himself a respected artist, dies of tuberculosis

1899　Completes series of mission paintings

Publishes *The Twenty-one Missions of California*

1900　Exhibits mission series at San Francisco's Palace Hotel

1903　Meets with other artists to establish an association of professional artists in Alameda County

1906　April 18: The San Francisco earthquake redirects the course of Deakin's work

1907　Continues to exhibit at his Berkeley studio and at the new Piedmont Art Gallery

1914　April: Exhibits the mission series in his Berkeley studio

1915　Begins to paint buildings of the 1915 Panama-Pacific International Exposition

Celebrates fiftieth wedding anniversary

1918　June: Holds retrospective of his work at his Berkeley studio

1922　Becomes seriously ill at Christmas, but health improves

1923　May 11: Dies suddenly in Berkeley, at nearly eighty-five years of age

1927　April: Small exhibition of Deakin's work held at Hotel Claremont

1940　*Flaming Tokay Grapes* exhibited in *California Art in Retrospect* at the Golden Gate International Exposition

1947　Bill presented before the California State Senate Finance Committee to purchase the mission paintings; it fails to pass

Deakin's daughter Dorothy decides to will nineteen of his paintings to the State of California

1955–1956　Second mission series donated to the Franciscan Friars of California

1959　Los Angeles Museum of History, Science, and Art acquires first mission series

1960　September 14–December 24: First museum-sponsored exhibition of Deakin's work, *The Twenty-one Edwin Deakin Mission Paintings,* held at the Los Angeles Museum of History, Science, and Art

1963　April 22–May 11: Exhibition of Deakin's oil sketches held at Alta California Bookstore in Berkeley

1969　Exhibition of mission paintings held at The Oakland Museum, Kaiser Center Gallery

2006　State of California's Department of Finance transfers nineteen paintings to Crocker Art Museum, Sacramento

2008　Crocker Art Museum hosts exhibition and publishes catalogue, *Edwin Deakin: California Painter of the Picturesque*

SELECTED BIBLIOGRAPHY

ARCHIVAL AND UNPUBLISHED SOURCES

Catalogue: Exhibition of "The Emerald Pool," *White Mountains* by A. Bierstadt, and Other Paintings. San Francisco: Snow & Roos' Art Gallery, Aug. 1871.

Catalogue of a Special Artist's Sale of Oil Paintings. San Francisco: H. M. Newhall and Co., Auctioneers, May 21, 1873.

Catalogue of Oil Paintings. San Francisco: Easton and Eldridge, Auctioneers, Nov. 10, 1886.

Catalogue of Paintings Sale. San Francisco: H. M. Newhall and Co., Auctioneers, May 19, 1880.

Deakin, Edwin. Artist's Biographical Card. Edwin Deakin file, California History Section, California State Library, Sacramento.

Deakin, Edwin. Papers. Archives of American Art, Smithsonian Institution, Washington, D.C. Roll no. 4201, frames 1–77.

Deakin, Robert. Papers. Archives of American Art, Smithsonian Institution, Washington, D.C. Roll no. 4201, frames 78–128.

Edwin Deakin File. Oakland Museum of California.

Jennings, Charlotte Rabbitt. "Edwin Deakin's Scrapbook of His Sketches of the California Missions." M.A. thesis, University of California, Santa Barbara, 1978.

North Point Gallery, Archive of Newspaper Clippings Relevant to Early California Art. Edwin Deakin Files, San Francisco.

BOOKS

Anderson, Antony, et al. *Art in California: A Survey of American Art with Special Reference to Californian Painting, Sculpture and Architecture Past and Present, Particularly as Those Arts Were Represented at the Panama-Pacific International Exposition.* San Francisco: R. L. Bernier, 1916; reprinted, Irvine, Calif.: Westphal Publishing, 1988.

Atherton, Gertrude. *Before the Gringo Came.* New York: J. Selwin Tait & Sons, 1894.

Cornelius, Brother [Fidelis] F.S.C., M.A. *Keith: Old Master of California.* 2 vols. New York: G. P. Putnam's Sons, 1942.

Deakin, Edwin. *The Twenty-one Missions of California.* Berkeley, 1899.

Field, Isobel. *This Life I've Loved.* New York and Toronto: Longmans, Green and Company, 1937.

Fink, Lois Marie. *American Art at the Nineteenth-Century Paris Salons.* Washington, D.C., and Cambridge: National Museum of American Art, Smithsonian Institution, and Cambridge University Press, 1990.

Ford, Henry Chapman, edited and with an introduction by Norman Neuerburg. *An Artist Records the California Missions.* San Francisco: Book Club of California, 1989.

Gerdts, William H., *Art Across America: Two Centuries of Regional Painting, 1710–1920.* 3 vols. New York: Abbeville Press, 1990.

Gerdts, William H., and Russell Burke. *American Still-Life Painting.* New York, Washington, and London: Praeger Publishers, 1971.

Halteman, Ellen, comp. *Publications in California Art No. 7: Exhibition Record of the San Francisco Art Association, 1872–1915; Mechanics' Institute, 1857–1899; California State Agricultural Society, 1856–1902.* Los Angeles: Dustin Publications, 2000.

Haskell, Albert G. *A Rosary of California's Early Spanish Missions for the Indians on El Camino Real.* San Francisco: Old Missions Publishing Company, n.d.

Hjalmarson, Birgitta. *Artful Players: Artistic Life in Early San Francisco.* Los Angeles: Balcony Press, 1999.

Hughes, Edan Milton. *Artists in California, 1786–1940.* 2 vols. 3rd ed. Sacramento: Crocker Art Museum, 2002.

Jackson, Helen Hunt. *Glimpses of California and the Missions.* Illustrations by Henry Sandham. The Century Company, 1883; reprinted, Boston: Little, Brown and Company, 1902.

———. *Ramona: A Story.* Introduction by A. C. Vroman. Roberts Brothers, 1884; reprinted, Boston: Little, Brown and Company, 1913.

James, George Wharton. *California Romantic and Beautiful.* Boston: Page Company, 1914.

———. *In and Out of the Old Missions of California: An Historical and Pictorial Account of the Franciscan Missions.* Boston: Little, Brown and Company, 1924.

Jewell, James Earl, ed. *The Visual Arts in Bohemia: 125 Years of Artistic Creativity in the Bohemian Club.* San Francisco: Annals of the Bohemian Club, 1997.

Keeler, Charles Augustus. *The Simple Home.* San Francisco: Paul Elder, 1904; reprinted, with an introduction by Dimitri Shipounoff, Santa Barbara: Peregrine Smith, 1979.

Lears, T. J. Jackson. *No Place of Grace: Antimodernism and the Transformation of American Culture, 1880–1920.* Chicago and London: The University of Chicago Press, 1981.

Lewis, Oscar. *Bay Window Bohemia: An Account of the Brilliant Artistic World of Gaslit San Francisco.* Garden City, N.Y.: Doubleday & Company, 1956.

Mahood, Ruth I., ed. *A Gallery of California Mission Paintings by Edwin Deakin.* Los Angeles: Los Angeles County Museum of Natural History, 1966.

Markham, Edwin. *California the Wonderful: Her Romantic History, Her Picturesque People, Her Wild Shores, Her Desert Mystery, Her Valley Loveliness, Her Mountain Glory, Including Her Varied Resources, Her Commercial Greatness, Her Intellectual Achievements, Her Expanding Hopes, With Glimpses of Oregon and Washington, Her Northern Neighbors.* New York: Hearst's International Library Company, 1914.

Moure, Nancy Dustin Wall. *California Art: 450 Years of Painting and Other Media.* Los Angeles: Dustin Publications, 1998.

Muir, John, ed. *Picturesque California and the Region West of the Rocky Mountains from Alaska to Mexico.* 5 vols. New York and San Francisco: J. Dewing Company, 1888.

———. *The Yosemite.* The Century Company, 1912; reprinted, Garden City, New York: Anchor Books, Doubleday & Company, 1962.

Mumford, Lewis. *The Brown Decades: A Study of the Arts in America 1865–1895.* Harcourt, Brace and Company, 1931; reprinted, New York: Dover Publications, 1971.

Neuhaus, Eugen. *The Art of the Exposition: Personal Impressions of the Architecture, Sculpture, Mural Decorations, Color Scheme & Other Aesthetic Aspects of the Panama-Pacific International Exposition.* San Francisco: Paul Elder and Company, 1915.

Newcomb, Rexford. *The Old Mission Churches and Historic Houses of California: Their History, Architecture, Art, and Lore.* Philadelphia & London: J. B. Lippincott Company, 1925.

Novak, Barbara. *Nature and Culture: American Landscape Painting, 1825–1875.* New York: Oxford University Press, 1980.

Peixotto, Ernest. *Romantic California.* New York: Charles Scribner's Sons, 1910.

Schwartz, Ellen, comp. *Nineteenth-Century San Francisco Art Exhibition Catalogues: A Descriptive Checklist and Index.* Davis, Calif.: Library Associates, University of California, Davis, 1981.

Schwartz, Ellen Halteman, comp. *Northern California Art Exhibition Catalogues (1878–1915): A Descriptive Checklist and Index.* La Jolla, Calif.: Laurence McGilvery, 1990.

Starr, Kevin. *Americans and the California Dream, 1850–1915.* New York: Oxford University Press, 1973.

———. *Inventing the Dream: California Through the Progressive Era.* New York and Oxford: Oxford University Press, 1985.

Stoddard, Charles Warren. *In the Footprints of the Padres.* San Francisco: A. M. Robertson, 1901.

Van Nostrand, Jeanne. *The First Hundred Years of Painting in California, 1775–1875.* Foreword by Alfred Frankenstein. San Francisco: John Howell—Books, 1980.

———. *A Pictorial and Narrative History of Monterey, Adobe Capital of California, 1770–1847.* San Francisco: California Historical Society, 1968.

Vincent, Stephen, ed. *O California! Nineteenth and Early Twentieth Century California Landscapes and Observations.* Preface by Kevin Starr. San Francisco: Bedford Arts, Publishers, 1990.

Westphal, Ruth Lilly, ed. *Plein Air Painters of California: The North.* Irvine, Calif.: Westphal Publishing, 1986.

———. *Plein Air Painters of California: The Southland.* Irvine, Calif.: Westphal Publishing, 1982.

Exhibition Catalogues

Alta California Bookstore. *Edwin Deakin 1838–1923: An Exhibition of Paintings and Sketches.* Berkeley: Alta California Bookstore, 1963.

Andersen, Timothy J., Eudorah M. Moore, and Robert W. Winter, eds. *California Design, 1910.* Pasadena, Calif.: California Design Publications, 1974.

Arkelian, Marjorie. *The Kahn Collection of Nineteenth-Century Paintings by Artists in California.* Oakland: The Oakland Museum, 1975.

Baird, Joseph Armstrong, Jr. *Views of Yosemite: The Last Stance of the Romantic Landscape.* Fresno, Calif.: Fresno Arts Center, 1982.

Barron, Stephanie, Sheri Bernstein, and Ilene Susan Fort. *Made in California: Art, Image, and Identity, 1900–2000.* Berkeley, Los Angeles, and London: Los Angeles County Museum of Art and University of California Press, 2000.

Corn, Wanda. *The Color of Mood: American Tonalism 1880–1910.* San Francisco: M. H. de Young Memorial Museum and the California Palace of the Legion of Honor, 1972.

Driesbach, Janice T. *Bountiful Harvest: 19th-Century California Still Life Painting.* Sacramento: Crocker Art Museum, 1991.

Ferber, Linda S., and William H. Gerdts. *The New Path: Ruskin and the American Pre-Raphaelites.* Brooklyn: The Brooklyn Museum, 1985.

Gerdts, William H. *Painters of the Humble Truth: Masterpieces of American Still Life, 1801–1939.* Columbia and London: Philbrook Art Center with University of Missouri Press, 1981.

Harrison, Alfred C., Jr. *William Keith: The Saint Mary's College Collection.* Edited by Ann Harlow. Moraga, Calif.: Hearst Art Gallery, Saint Mary's College of California, 1988.

Miller, Dwight. *California Landscape Painting 1860–1885: Artists Around Keith and Hill.* Stanford, Calif.: Stanford Art Gallery, 1976.

Neubert, George W., and Marjorie Arkelian. *Tropical: Tropical Scenes by Nineteenth-Century Painters of California.* Oakland: The Oakland Museum, 1971.

Stern, Jean, et al. *Romance of the Bells: The California Missions in Art.* Irvine, Calif.: The Irvine Museum, 1995.

Trapp, Kenneth R., et al. *The Arts and Crafts Movement in California: Living the Good Life.* Oakland: The Oakland Museum, 1993.

Truettner, William C. *The West as America: Reinterpreting Images of the Frontier.* Washington, D.C.: Smithsonian Institution Press/National Museum of American Art, 1991.

Wilson, Raymond L. *William Keith: A Changing Vision.* Fresno, Calif.: Fresno Art Center, 1984.

Periodicals

Bird, Pauline R. "The Painter of the California Missions." *The Outlook* 76 (Jan. 1904): 74–80.

Carman, Bliss. "The Use of Out of Doors." *Craftsman* 11 (Jan. 1907): 422–425.

Estrada, Dolores. "The Passing of the Spanish in California." *Overland Monthly* 46 (July 1905): 28–31.

Gebhard, David. "Architectural Imagery, the Mission, and California." *The Harvard Architecture Review* 1 (Spring 1980): 137–145.

Hewitt, Robert L. "Edwin Deakin: An Artist with a Mission." *Brush and Pencil* 15 (Jan. 1905). Typescript. Edwin Deakin File. Oakland Museum of California.

Hudson, Charles Bradford. "Monterey on the Etching Plate." *Sunset* 35 (Aug. 1915): 298–302.

Kothe, Leonore. "In Old Monterey." *Overland Monthly* 57 (June 1911): 631–635.

Shoup, Paul. "An Old Story in Crumbling Walls." *Sunset* 4 (Apr. 1900): 244–245.

Stoddard, Charles Warren. "Old Monterey." *Sunset* 16 (Feb. 1906): 358–359.

Williams, Michael. "The Founder of California." *Sunset* 31 (Nov. 1913): 947–954.

ALPHABETICAL LIST OF DEAKIN ARTWORKS

INDEX

Italic numbers indicate artwork or photographs.